THE MCGRAW-HILL

MUSEUM-GOER'S GUIDE

RICHARD WINK

RICHARD PHIPPS

Boston Burr Ridge, IL Dubuque, IA Madison, WI
New York San Francisco St. Louis
Bangkok Bogotá Caracas Lisbon London Madrid Mexico City
Milan New Delhi Seoul Singapore Sydney Taipei Toronto

McGraw-Hill Higher Education ✎

A Division of The **McGraw-Hill** Companies

The McGraw-Hill Museum-Goer's Guide

This book is printed on acid-free paper.

3 4 5 6 7 8 9 0 DOC/DOC 0 9 8 7 6 5 4 3 2 1 0

ISBN 0-07-038731-1

Editorial director: *Phillip A. Butcher*
Executive editor: *Cynthia Ward*
Marketing manager: *David Patterson*
Project manager: *Amy Hill*
Production supervisor: *Michael R. McCormick*
Interior designer: *Michael Warrell*
Cover designer: *Andrew Curtis*
Cover photo: © *Tony Stone*
Senior photo research coordinator: *Keri Johnson*
Supplement coordinator: *Marc Mattson*
Compositor: *Carlisle Communications, Ltd.*
Typeface: *10/12 Versailles*
Printer: *R. R. Donnelley & Sons Company*

http://www.mhhe.com

CONTENTS

CONTENTS

CHAPTER 4 BRINGING THE MUSEUM HOME 69

HOW TO USE THIS GUIDE

A stockbroker once confided to us that he visits art museums as an escape from the world he normally inhabits, away from reality in a tranquil place whose sole function is the preservation, presentation, and protection of visual beauty. Like many other laypersons, he takes great pleasure in simply allowing the art to speak to him in a nonconfrontational manner. This is certainly one of the many effective and legitimate ways to visit a museum. On the other hand, we have found that the museum experience can become much more fruitful and fulfilling as a result of more active and substantial interactions with artworks.

This guide is designed to make your visit comfortable as well as productive—an experience to remember and build upon with subsequent visits to museums located in all corners of the globe. You are encouraged to take this book with you to the art museum where you can refer to the visual analysis guide as you take notes and make sketches on the pages provided. The contents are divided into four parts:

Chapter One is an overview of the history, purposes, and functions of art museums. It also introduces you to types of art and the rationale behind the exhibition of works found there.

Chapter Two contains activities designed to prepare you for a visit, including how to analyze a work of art and how to sketch and take notes on specific artworks that appeal to you.

Chapter Three suggests various exercises which may be completed during your tour of a museum.

Chapter Four suggests several ways you can take the museum home in the form of writing projects and making your own works of art.

The glossary provides definitions of art terms, along with selected pronunciation aids, likely to be encountered during a museum visit.

A list of prominent museums in the United States and Canada is provided in the back of the book. This list, which features the museums' addresses, phone numbers, and Web sites, may be of some use in preparing for a visit, especially in the event you are traveling to another city.

Use the guide as needed. If you already are familiar with the history of museums and how they operate, you may choose to go directly on. The same is true for Chapter Two— a number of people sketch very well and have had experience with taking notes about what they observe.

The exercises in Chapter Three are presented in a relatively progressive order; we suggest you pick and choose among them according to your own interests and needs. Chapter Four offers suggestions for writing projects and making your own art based on discoveries made during the visit. Your notes and sketches will come in handy here.

Recent studies have shown that the frequency of visits to art museums is on the rise. New York City's Metropolitan Museum of Art is visited by more people per year than all athletic events in that city put together. If you're not already part of the excitement of discovering art, what better time than right now?

MUSEUM PROFILE

EXPLORING AN ART MUSEUM

There is no substitute for the real thing. Most of us view fine art by way of reproductions seen in art books, on cards and posters. And while these copies can sometimes be quite handsome in color and clarity, they cannot compare with firsthand encounters with original works of art. Most sculpture, for example, should be viewed from multiple angles; paintings are almost never represented true to size in reproductions and the frames are usually excluded in textbooks and museum catalogs. Color is yet another factor: reproductions often misrepresent the true hues of an original painting, and many are printed in black and white.

But the most important aspect of a museum visit is that inexplicable aura one senses when viewing an original work of art, especially one created by a world-famous artist. And this aura is enhanced by the ambiance of the museum setting itself, set apart from the real world—secluded, quiet, and made perfect for displaying and viewing art. It is here that significant experiences with art are most likely to take place. From ancient Egyptian wall paintings to the provocative new art works of today, we can observe the great hopes, despair, longing, tragedy, and faith of people throughout history all over the world. Great art works have the capacity to reveal a comprehensive, personal, and incisive view of the time and

place in which artists lived and worked. The world's most priceless art treasures must have a home where they are safe from theft, vandalism, and the ravages of time. The basic purpose of any museum is to do everything it can to bring the world's greatest art to the public so that it can be viewed under ideal conditions.

A BRIEF HISTORY In ancient Greece, the word *mouseion* referred to sanctuaries dedicated to the Muses, nine sister goddesses who presided over learning and the creative arts. The *mouseion* at Alexandria, Egypt, established c. 290 B.C. by a group of scholars, was the first instance where a place was set aside for exhibiting collections of artistic, scientific, and historical objects. These sanctuaries also comprised botanical and zoological parks and presented productions in music, drama, and dance. After the decline of the ancient world, collections were dispersed and the *mouseion* temporarily disappeared.

In Europe, during the period from A.D. 400 to 1400, art objects were kept in churches and monasteries. During the Renaissance (c. fourteenth to sixteenth centuries), wealthy people began to amass collections which, in the tradition of the early *mouseion,* contained a variety of items. Cabinets of curiosities displayed horns of narwhals as unicorn horns purported to have magical powers; skeletal remains of elephants were displayed as the bones of giants; and mummies were prized for the powder they contained which was believed to have healing properties.

Since that time, art collections have taken on a variety of forms. In sixteenth-century Europe, Paolo Giovio, a bishop, collected portraits of famous men; he revived and brought into general use the word *museum* and his collection, the Museum Jovianum, became widely known. Collections of historical value became popular with wealthy collectors such as the Medicis of Italy. Catherine the Great, Empress of Russia from 1762 to 1796, owned a "Cabinet of Muses and Graces" which contained likenesses of Europe's most beautiful women. It was also during this period that easel paintings and sculpture were displayed in long hallways, or galleries, in palaces of the wealthy. The term

gallery now refers to a room for displaying art in a museum or to an institution that sells art.

As the nationalistic spirit pervaded Europe, national museums were established to collect symbols of past greatness. "Battle galleries" consciously sought to instill a love for wartime glory. Louis Philippe established the Historical Museum at Versailles in 1837; its Gallery of Battles, 400 feet in length, held a painting depicting Napoleon's victories. Although the British Museum in London and the Louvre in Paris were both established as public museums as early as the eighteenth century (1753 and 1793 respectively), museums as we know them today appeared and grew prolifically in the late 1800s, appearing in such larger cities of the United States as Boston, New York, and Philadelphia.

Prior to the twentieth century, museums commonly collected all manner of scientific, literary, historical, and artistic items. Such heterogeneous collections reflected the belief of the eighteenth-century Enlightenment proposing that people should be interested in all areas of knowledge. However, this overextension soon resulted in a bewildering montage of art, anthropological objects, and unique curiosities which seemed to cry out for specialization. Collectors thus began to organize their vast array of disparate objects into specific subject areas. Individual collections were often passed on to agencies that developed a concentration of objects that appealed to particular interests. With the advent of specialization, the great storehouse concept of the museum was gradually modified and museums devoted exclusively to art came into being.

MUSEUMS AS ARTWORKS During your next visit to a museum, take special notice of its design. The architect planned the structure to serve a specific purpose that is meant to have an impact on museum visitors. How does a particular museum's design affect your experience with its artwork?

One of the most distinctive and renowned structures in the world of art is The Solomon R. Guggenheim Museum of Art in New York City (Fig. 1.1). Frank Lloyd Wright designed this museum around a simple, unifying element: the inverted

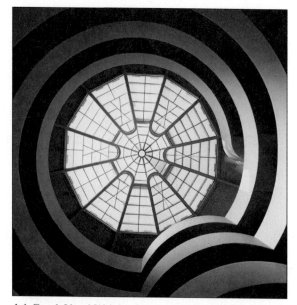

1.1 Frank Lloyd Wright: Solomon R. Guggenheim *Museum, New York, Interior view. 1956–59. (Photograph by David Heald © The Solomon R. Guggenheim Foundation, New York.)*

spiral. As visitors enter, they are encouraged to cross an open display area to the elevator. Reaching the top level, they begin their effortless stroll down a spiral ramp past the artworks which hang on the wall to their left. On their right is a large open core of light and space. This is truly a unique museum and a thing of beauty in itself.

One of the most exciting new developments in modern museum architecture opened its doors to the public in October 1997. Resembling a large contemporary sculpture, architect Frank O. Gehry's meandering towers of The Guggenheim Museum Bilbao in Spain (Fig. 1.2) mirror the museum's collection of large-scale contemporary art. A major concern of many architects is how the interior spaces and the exterior are interdependent with the function the structure serves, or how—to implement the expression coined by American architect Louis Sullivan (1856–1924)—"form follows function."

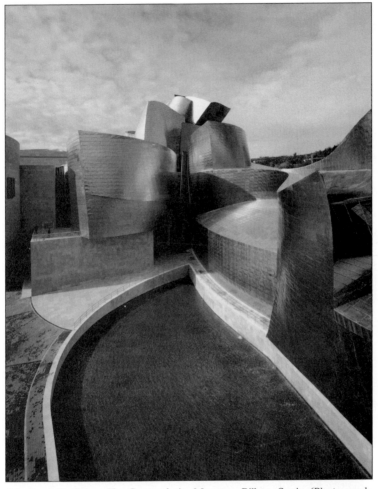

1.2 Frank O. Gehry: The Guggenheim Museum, Bilbao, Spain. (Photograph © The Solomon R. Guggenheim Foundation, New York.)

The Guggenheim in New York exemplifies this principle: the spiral effect, with its functional viewing ramp, constitutes the major theme of the building both outside and within. Can you imagine the interior of the Guggenheim Bilbao?

Another spectacular example is the Louvre, located in the heart of Paris (Fig. 1.3). Originally a king's palace, the

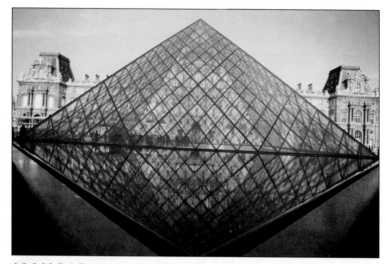

1.3 I. M. Pei: Entrance to The Louvre, Paris. (Art Resource, New York.)

Louvre has housed royal art treasures since the thirteenth century. It did not become an official museum until 1793, just after the French Revolution. All royal buildings became the property of the French people at that time, and the Louvre was chosen to exhibit the vast art collection that also suddenly belonged to the people. During the next few years, especially as a result of Napoleon's conquests, the collection of art grew at an extraordinary rate. The Louvre now owns some of the most important and well-known artworks in the world, including the *Venus de Milo, Victory of Samothrace,* and the *Mona Lisa.*

WHAT IS AN ART MUSEUM?

MUSEUM ORGANIZATION Art museums, especially large metropolitan institutions, are organized and managed in a manner similar to that of a large corporation. A governing board of trustees is responsible for establishing and maintaining institutional policy. Accordingly, the board hires a museum director who serves as the CEO; directors

are also called curators in the sense that they "take care of" the museum and its collections.

The museum staff usually includes curators of individual departments, such as Curator of Modern Art or Curator of the Renaissance Collection, who make decisions regarding the acquisition, preservation, and display of artworks. These functions largely comprise an art museum's reason for being. Large metropolitan museums will also have librarians, conservators, restorers, and art educators.

ACQUISITION The first and most important function of museums is procuring works of art through donations and purchase. If curators are interested in purchasing works by established masters, the price could easily be well beyond their established budget. Renewed interest in works by the great masters of history and their rarity have caused prices to skyrocket. Some of van Gogh's works have recently sold well in excess of 50 million dollars each, reflecting the public's current passion for Impressionist and post-Impressionist paintings. Such interests can easily change over time and those prices could plummet. Works by contemporary artists, on the other hand, are usually more reasonable and are purchased through art dealers or at auction houses where competitive bidding determines prices.

The permanent collections of most museums have benefited greatly from donations of private collectors. Museum labels often list the donor's name along with other pertinent information about the work.

The quality of its permanent collection gives each museum its own unique character. **Acquisition** is often the result of a well-organized plan of museum directors and curators whose decisions are based not only on their interests and expertise but also consideration for balance between works from various period styles in history and between types of art, such as paintings, sculpture, prints, drawings, photographs, and the like.

PRESERVATION Artworks tend to deteriorate. Leonardo's *Last Supper,* painted for a church in Milan, Italy, began to decay even before the artist could finish it, due in

large measure to his experiment with an untried wall painting technique. But even the most carefully executed works can rot, crumble, or disintegrate over time unless preventive measures are taken.

The **preservation** of a collection is a continuing process encompassing a controlled environment and proper housing for objects, measures to prevent further deterioration, and restoring damaged works. Changes in temperature and humidity and chemical pollutants in the air can all lead to the destruction of art works. Because high intensity light alters colors in art objects, cameras with flash attachments are usually prohibited in museums.

Special lighting, air filters, and humidity and temperature controls are installed for the protection of art works; many objects are housed in cases not only to protect them from dust and theft, but also to avoid unintentional damage caused by visitors. Museum regulations requiring visitors to check large bags and umbrellas and prohibitions of eating and drinking in the galleries are simply preservation precautions.

However, regardless of precautions, some items naturally disintegrate. Museum conservators with special training repair works that have been damaged or which have deteriorated over time. Layers of yellowed varnish are removed from old paintings to reveal the brighter, original colors beneath. Areas where paint has been lost are retouched—a process known as "in-painting." Although preservation procedures are less visible to the visitor than other museum functions, they are vital in ensuring the art objects' longevity.

One of the most heralded and controversial preservation projects in recent times was the nine-year restoration of the Sistine Chapel in Rome. Centuries of dirt, soot, and other foreign matter had darkened the images; cleaning restored Michelangelo's figures to what was thought to be their original brilliant coloration, value, and contrast. Critics of the procedure argued that those bright new hues do not constitute Michelangelo's original palette; others thought that the smoky patina that had developed over time provided the images with a natural, unified richness that was lost in the restoration process.

EDUCATION As important as they are, the acquisition and preservation of collections represent only part of the museum's function; the next step is gathering and transmitting knowledge about works in their collection. Large museums maintain departments of education whose responsibility is to provide a variety of programs and services that assist visitors in using their facilities and understanding their collections. Depending on the resources available and the philosophy of the board, each museum's education program is uniquely designed to fit its own situation. New York's Metropolitan Museum of Art, for example, offers a sophisticated program to teach parents how to assist children in making and appreciating art. Many museums have established their own publishing imprints to provide catalogs, brochures, gallery information sheets, and posters to help the public understand the museum's services.

In addition, performances, workshops, special tours, lectures, computer-assisted instruction seminars, and videotapes are also offered by museum educators. It is partly due to the efforts of the education staff that many outreach activities take place beyond the museum's walls, including traveling exhibits, gallery films, slide lecture sets, and staff lectures to schools and special interest groups. As you can see, educational activities are diverse and reflect the unique, self-structured nature of the museum experience.

DISPLAY In early museums where collecting was the major goal, cases were crowded, unlabeled objects were more or less thrown together, and pictures were hung frame-to-frame from floor to ceiling. Visitors were not only challenged to find works that appealed to them, they also had to fight distractions in viewing them. Exhibit design is now regarded as one of the museum's primary instruments of communication. Because perceptions of a work of art are affected by the way it is seen, curators consider the goals of the exhibit, the type and number of objects used, and their overall arrangement.

One of the most important factors in exhibition design is lighting. Changes in light intensity can lure visitors and

encourage them to look more closely at certain art works. Audio devices are often provided during special exhibits to provide information about selected works. Visitors may stroll along at their own pace, turning the recorded lecture on and off at their leisure. Literature about special exhibitions is always available in the form of free brochures; catalogs may also be printed especially for these exhibitions and offered for sale.

Exhibits are arranged in a variety of ways. Some museums, like the National Gallery of London and the Uffizi in Florence, arrange their **displays** chronologically. A rather unique feature at the Uffizi is a long U-shaped hallway that allows discriminating visitors to proceed directly to any spot in history that appeals to their taste, or their particular preference at the moment. The Dallas Museum of Art is also arranged chronologically, beginning with earliest cultures and art objects located on the top floor to contemporary art on the first floor. There are other museums that organize exhibits according to artist, medium, and country of origin. One of the most spectacular museum displays in the world is the Egyptian Gallery at the British Museum in London. Monumental sculpture, giant columns, and the famous Rosetta Stone provide a stunning view of ancient Egypt.

Visual communication has never been an exact science; there is no way that art objects can ever be presented in a manner which will guarantee that everyone will respond to them enthusiastically. But exhibit designers make every effort to ensure that works are presented clearly and without undue distraction. Keep in mind also that only a tiny fraction of the artworks a museum owns—its permanent collection—can ever be exhibited at any one time. What you see is the curators' current choice of those works that best represent their holdings.

In the museum you are visiting, you may come upon a blank space on a gallery wall with only a tag indicating that the work of art that normally hangs there is on temporary loan to another museum. All galleries and museums hold special exhibitions that last for only a matter of weeks. Works are selected from the permanent collections of many other museums and displayed with a chosen theme, such as "Ancient

Egypt," or "Impressionism," or the works of a particular artist or group of artists. Because of the expense of preparing these special exhibitions, an additional fee is usually charged for admittance. Sometimes these special exhibitions are simply traveling shows, or groups of works gathered together and scheduled for display in selected museums and galleries around the world.

TYPES OF ART FOUND IN MUSEUMS

Whenever we think of museums, paintings and sculpture first come to mind, but we can also see drawings, **prints,** photographs, **ceramics,** textiles, and even films. Paintings are most often exhibited in galleries and are grouped according to where and when they were painted. Paintings appear in many sizes, or **formats,** ranging from miniatures as small as postage stamps to oversized canvases that may cover an entire wall.

Some paintings are made in two or three pieces: A **diptych** painting (Fig. 1.4) consists of two panels, or screens, and a **triptych** has three. Some of these works were made as part of the altar in a church (called an **altarpiece**) and possibly meant to be folded, showing different images on the other side. Most paintings are rectangular, hanging horizontally or vertically, but some are square, circular (called a **tondo**) (Fig. 1.5), and others form irregular shapes. Those painted in wet plaster on walls and ceilings are called **frescoes**. In the Far East, paintings on screens and scrolls are popular.

Three-dimensional sculptures are sometimes grouped together in special exhibits inside the museum, and some are placed outside the museum's walls in a **sculpture garden.** Some of these works, especially those in bronze and other metals, acquire a weathered **patina** which, while pleasing to the eye, means that the work is deteriorating. Curators must therefore keep watch over the devastating effects of atmospheric damage and take steps to prevent it.

Many sculpted figures have missing parts: heads, arms, legs. We have come to accept them as finished pieces in

11

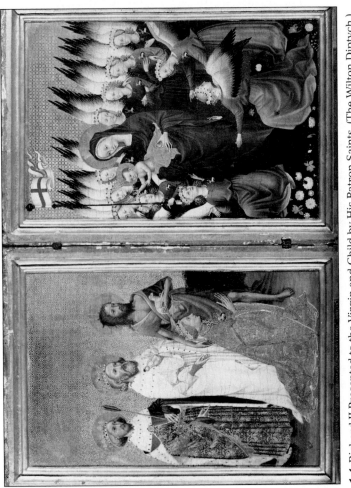

1.4 Richard II Presented to the Virgin and Child by His Patron Saints. (The Wilton Diptych.) *c. 1395 or later. Wood: each panel 45.7 × 29.2 cm. The National Gallery, London.*

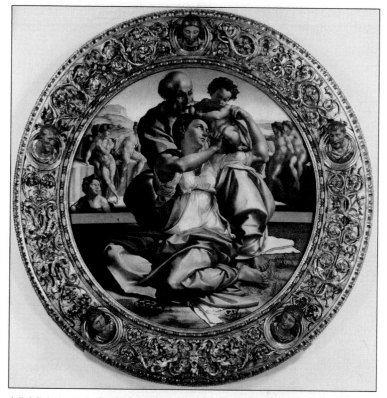

1.5 Michelangelo Buonarroti: Holy Family (Doni Tondo). *1506/8. Tempera on wood. Frame with five sculpted heads designed by Michelangelo. (S0009654 AL67381. B&W Print. Alinari/Art Resource, NY)*

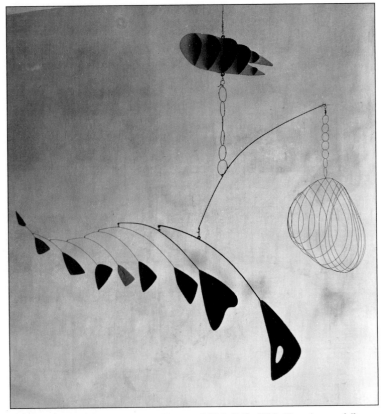

1.6 *Alexander Calder.* Lobster Trap and Fish Tail. *1939. Hanging mobile: painted steel wire and sheet aluminum, about 8'6" h. × 9'6" diameter (260 × 290 cm). The Museum of Modern Art, New York. (Commissioned by the Advisory Committee for the stairwell of the Museum. Photograph © 1998 The Museum of Modern Art, New York.)*

terms of their total composition; that is, how those remaining parts relate to one another to form that particular composition—not necessarily how they represent reality. Classic examples include the *Venus de Milo* at the Louvre Museum in Paris, whose graceful posture and flowing drapery suggest movement despite her lack of arms, and the *Victory of Samothrace,* also at the Louvre, whose magnificent

wings help to define her enduring grace and ideal beauty even without arms and head.

Artists create three-dimensional sculpture so that it can be viewed from many angles. Sculpture made with moving parts are called **mobiles** (Fig. 1.6), especially those whose parts are balanced in such a way to move with air currents.

Drawings in such media as pencil or pen and ink are sometimes exhibited in rooms which light up only when visitors approach—yet another attempt at preservation. **Etchings, silk screens, lithographs,** and photographs are usually produced in multiples and have a unique system of numbering. For example, an artist creates an original, then decides to print 100 copies. This is called a "limited edition" because the run is limited to 100. The artist usually signs, numbers, and dates (See Fig. 1.7) each of the 100 prints. After all prints are made, the artist may destroy the original wood block so that each print can be considered an original work of art and can sometimes become quite valuable.

Special rooms are sometimes set aside for such areas of the fine arts as film, photography, works in fiber, and other pieces in ceramics, glass, and design graphics, or industrial design.

Occasionally museum visitors encounter **installations,** works which are often composed of many separate pieces, conceived and arranged by the artist and "installed" in the museum and intended to be experienced as composites (Fig. 1.8). Materials used in such works range from stones to neon lights and may be temporary or permanent.

DEALING WITH ABSTRACT ART Depending on the particular museum you choose to visit and your objectives, you may encounter a significant number of **abstract** works and nonrepresentational (also called **"nonobjective"**) works. Abstract art results when the artist begins with real objects and then expresses characteristics differently through distortion, omission, or exaggeration of pictorial detail as seen in Picasso's *Three Musicians* (Color Plate 2). **Nonrepresentational art** refers to that which is not based on real objects but rather deals only with elements of art, such as line, color, texture, forms, space and the like as seen

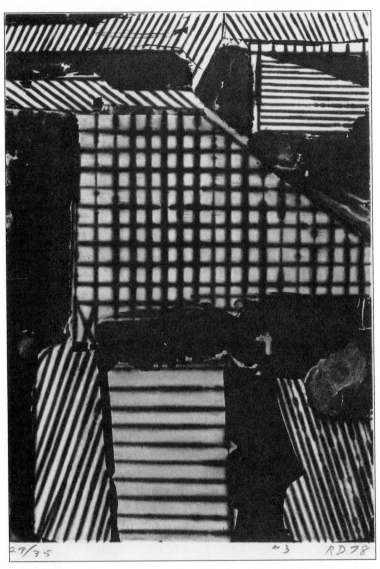

29/35 #3 RD 78

1.7 *Richard Diebenkorn: Untitled from* Five Aquatints with Drypoint. *1978. Aquatint with drypoint, printed in black, plate. 10 15/16 × 7 7/8" (27.8 × 20.0 cm). The Museum of Modern Art, New York. An example of how an artist signs prints, showing the number 29 in a run of 35; title (#3), artist's name or initials, and date. Other placements and selected types of identification are used depending on the preference of the printmaker. A/P denotes "artist's proof." These are not counted in a final run of copies. (John B. Turner Fund. Photograph © The Museum of Modern Art, New York.)*

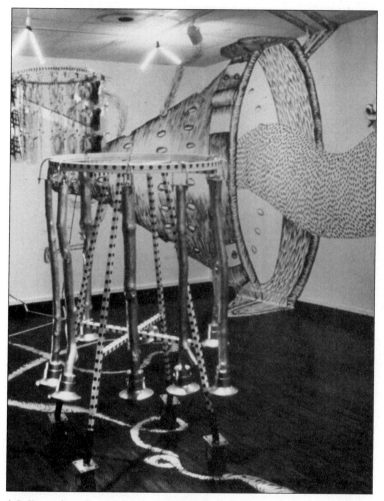

1.8 *Karen Snouffer:* Perforated Vanities II. *1997. Mixed media, installation view. Aprox. 15′ × 9′ × 20′. (Collection of the artist. Photography by Tony Walsh.)*

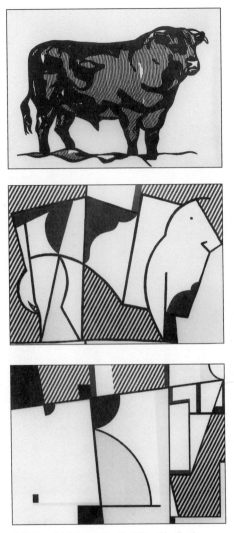

in Richard Diebenkorn's print, Fig. 1.7. Art does not always contain recognizable objects, but meaning may nevertheless be perceived if we look at it with a different frame of reference. A well-known example is Roy Lichtenstein's series of prints called the *Bull Profile Series* (Fig. 1.9) in which he began with a clearly recognizable bull and gradually reduced it to a few shapes and lines. If you were to see only the last printed image in the series, would you be able to accept it as a bull? Lichtenstein was no doubt challenging us to appreciate the importance of seeing something more basic than the realistic image of a bull. He eventually arrived at the *linear essence* of a bull, inviting viewers to see the bull in an entirely new way.

1.9 Roy Lichtenstein: Bull Profile Series: Bull I, Bull III and Bull V. *The artist reduced a realistic drawing to its linear essence. (© Estate of Roy Lichtenstein/Gemini G.E.L.)*

PROFILE OF A VISIT

A large museum can be quite intimidating for the beginner: huge portals, cavernous interiors, and those ever-present guards who seem to be watching your every move. Overcoming intimidation is not easy, but realize that you are not alone and remember that the museum and all of its staff are there to make your visit a pleasant and memorable experience.

After deciding on which museum to visit, you might like to follow these few hints to make the trip more efficient and productive. First, acquaint yourself with the museum's entire collection so that you may plan on what part of it you would like to see. Some collections are so vast that trying to take it all in during a single visit would be impractical. The Internet offers a wealth of information about most museums—their collections, special exhibits, and ancillary programs. At some point you should decide just what you will want to see during your visit and how much time to devote to it. A truly rewarding museum visit is surprisingly tiring; a few hours at a time is enough for most. Planning ahead will result in a much more fruitful experience.

There is no set way to visit a museum. Except for special exhibitions where pre-established traffic patterns are

planned, you can map your own course. Let us say, for example, that you want to check out what the museum has to offer; you don't want to examine each and every artwork—just walk through and glance casually at whatever is there. There is nothing wrong with that; in fact, if you plan a second visit, this procedure is highly recommended.

Ordinarily, the most productive visits are those which are planned around a specific purpose, such as a tour of the museum's contemporary art collection. You could decide that you will look at only those works that appeal to you and ignore all the others. You need not feel compelled to spend at least 15 minutes before the *Mona Lisa* simply because it is regarded as the Louvre's greatest art treasure. If it doesn't appeal to you, walk on by. Most likely, subsequent visits will result in a more widely accepted range of personal preferences, and those things that may not appeal to you now may become a passion later on.

Above all, be curious. Each museum visitor has his or her own way of seeing what a work of art has to offer. Consider the range: from the casual tourist just looking the place over, to some artists who, complete with brush and palette, spend hours in museums copying the works of great masters. For those learning what to look for in a work of art, it might be a good idea to follow a museum guide book or join a guided tour with a docent and take notes on those aspects of a work that you recognize or that seem to say something to you.

The quality and nature of your museum experience will depend a great deal on whether you go alone, with a close friend or with a group. Alone, you are not obligated to do anything, go anywhere or limit the time spent doing it. You wander about silently and react to art entirely in your own way.

Surprisingly, this may not be the best way to visit a museum. According to teacher, author, and lecturer Dr. Edmund Feldman, reacting to art in a critical manner is to *talk* about it. When alone, talking takes the form of notes and sketching, but, in the company of others, discussion brings out more than you thought you knew about art. The very act of conversation about art encourages you to look more carefully and to describe in better detail what you are looking at. You

progress, almost imperceptibly, from merely *looking* at art to-ward *seeing* what art is all about. Exposure and reaction to objects of art can be condensed to three major areas of concern: What type of artwork is it, who made it, and what do you see? How well is it put together? What does it express to you?

MUSEUM PROTOCOL

All large metropolitan museums supply maps, or floor plans, to help you find what you are looking for. You will notice right away that each floor of a museum is divided into historical period styles, geographical regions, and types of art. As you proceed through your tour, you might want to mark an ✕ on the map where you found works that you sketched and described in your notes.

You will see notices everywhere in museums that tell you, "Do Not Touch." The museum guards may tell you not to touch the artworks, or not to stand too close—they may even have a rope strung at a distance to make sure. Below are the actual words from signs in the Carnegie Art Museum in Pittsburgh:

Please Do Not Touch

*Even the gentle stroke of a finger can chip
or crack paint that is brittle with age. The
oils and acids in even the cleanest hands
can tarnish metal, stain textiles and wood,
and discolor marble and bronze.*
*Please help preserve these works of art for
future generations. The legacy is yours to leave.*

It is generally understood that visitors should not distract others in the museum from their quiet contemplation. It is much like a library in that sense. This is one of the reasons that museum officials often control large crowds drawn to special exhibitions by admitting only a limited number of people into the gallery at a time.

TECHNIQUES OF LOOKING AND SEEING

The more we know about a work of art, the greater our potential for appreciating it. In order to focus on various aspects of the visual experience, the Visual Analysis Guide is designed to be taken to a museum or gallery to help make more informed aesthetic responses to what you see. After completing the Identification section, respond to the remaining categories in any order.

VISUAL ANALYSIS GUIDE

Identifying the Basics

1. What is the object? (painting, drawing, print, sculpture, etc.)
2. Record the artist and title.
3. What is the medium?
4. Identify the subject matter.
5. When and where was it made?

Looking at the Formal Elements

6. Describe the use of line and texture.
7. Discuss color and value.
8. Describe the use of shapes and space.
9. What is the relationship between unity and variety?
10. Describe the use of motion and rhythm.
11. Describe the use of balance and proportion.

Thinking About the Cultural Context

12. Identify the content and central theme.
13. What is the style period?
14. Identify symbols, objects, people, places which reflect the cultural context.
15. What cultural concepts are expressed?
16. Discuss the object's original and current usage.
17. Compare the object with similar art forms.

Considering the Expressive Qualities

18. Describe the object's ability to convey emotions.
19. Does the object express ideas of present or past societies? If so, how?
20. What is your overall assessment of the work?

We offer the following analyses as examples of how you can approach any work of art using this guide:

IDENTIFICATION Identifying basic facts about an artwork is fairly obvious. Information appearing on a label accompanying each work reveals its title, the artist, date, medium and technique, subject, and place of origin. Take a look at Theodore Gericault's (jeh ree koh') *The Raft of the Medusa* (Color Plate 1). The label indicates that it is an oil painting, who painted it, when it was painted, its size and proportions. The subject matter depicts people on a makeshift raft desperately searching the troubled sea for rescue. The museum information sheet near this painting may well indicate that it represents a true-to-life disaster at sea—the aftermath of a wrecked French frigate called the *Medusa* off the coast of Africa in the early 1900s. The work dramatically illustrates survivors struggling to stay alive as they signal to another ship on the distant horizon. Of the over 150 souls aboard the ship, only 15 lived to drift on the raft until they were rescued.

FORMAL ELEMENTS Look for the artwork's technical aspects—the use of line, texture, mass and space, light and shade (light and dark value), and color. The arrangement of writhing figures in this painting move along a diagonal line from the lower left to the upper right, creating a sense of movement to the man at the top signaling to the distant ship. In this way, Gericault directs the viewer's path of vision diagonally from one section of the painting to another. Also, his changes in value from light to dark create dramatic contrasts emphasizing a strong light source from the left side of the canvas. No less significant is the sharp value contrast between water and sky. The lighter background of the sky enables the viewer to clearly distinguish the raft and the ship's

company in a compositional unit that forms two large pyramidal shapes. These two geometric patterns provide us with the basic compositional structure of the work.

Artists also use such lines, value, shapes, color and textures to create the illusion of depth in space from the foreground through the middle ground to the background. In particular, color plays a major role in establishing space relationships. There is no substitute for viewing an original work to experience these interconnections firsthand. All reproductions of Gericault's *Raft* in textbooks are somewhat dissimilar in color, tone, and detail from each other and from the original. Although no one is sure of the artist's palette in 1818, spectators fortunate enough to view the *Raft* in the Louvre may be surprised at the extent of darkening that has taken place over the years. Yet, the resulting browns and greens relate perfectly with the suffering and morbid subject matter. Also, Gericault's use of exaggerated modeling of human forms brings the figures to life.

The way artworks are put together can have an effect on the way we see them. In the case of the Gericault, unity is achieved by the overall mass of bodies huddled on the raft while variety is provided by the large sail and mast leaning in the opposite direction. These opposing forces also help to balance the composition asymmetrically instead of the more accepted classical, symmetrical approach of that period. Other powerful passages are located throughout the canvas. Note the many instances where diagonals are pushing and pulling, setting up repetitive rhythms which activate the entire canvas.

This is only a sample of the many combinations to be uncovered if we allow ourselves to read beyond the reality of subject matter and accept the forms as nonobjective lines and shapes intertwined in a collective mass. The dynamics of the *Raft,* as shown in Fig 2.1, are not an afterthought in terms of the thinking and planning of the artist. Such calculations begin early when the canvas contains only a rough, preliminary drawing, which more than likely was followed by more and more detailed delineation, assuring the artist of a final synthesis of the parts in relation to the whole.

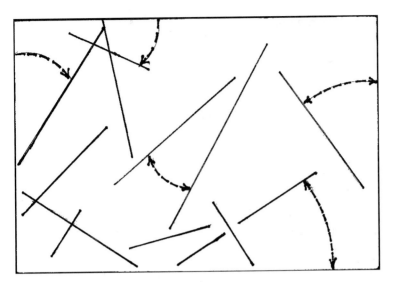

2.1 *A selection of opposing diagonal lines showing some of the many forces at work in Gericault's Raft. Arrows indicate the push–pull of diagonals as they create movement, tension, and struggle between the major passages in the painting.*

Prominent linear rhythms can be identified in most paintings and sculpture. Some works are based on vertical/horizontal shapes as seen in Picasso's *Three Musicians* (Color Plate 2). In still others, curvilinear shapes are found, like those in Van Gogh's *Starry Night* (Fig. 2.5). Consider whether or not these dominant linear rhythms appear to be significant in the creative process. Look through this guide for works by Duchamp, Boccioni, Moore, and others and decide if a dominant linear rhythm contributes to their overall expressive content.

THE CULTURAL CONTEXT Throughout history, art has served any number of functions. Since each work we encounter may reflect the tone of the place and period of time in which it was produced, we need to speculate on a variety of contextual questions: How was the object used in its time? What historical or legendary episodes are depicted? What is

the meaning of the symbols? What cultural concepts are expressed? Answering these questions can provide us with a means of understanding the society of the period. The Gericault painting appealed to the early nineteenth-century ideal of noble and heroic pursuits, and the painting's great size emphasizes the Romantic's quest for grandiose statements. The artist's imagination became more important than dazzling displays of artistic virtuosity. The period style associated with such works is called **Romanticism**, and subjects of the period were primarily exotic, mysterious, and vibrant with implied motion.

EXPRESSIVE QUALITIES Scholars have not always agreed on the best way to appreciate art. By referring to the Visual Analysis Guide, we can concentrate on specific areas of interest, and perhaps achieve a deeper appreciation of art than we could hope for in casual viewing. After some practice, the process will become more intuitive and referring to a guide will no longer be necessary. Almost any work of art can elicit a reaction from viewers, from "I could have done that," to "What does it mean?" or "I really like that." Such personal reactions to works of art are evidence that art has the power to communicate ideas and emotional responses, to remind us of events in our own lives, or to create a mood. Gericault's magnificent painting conveys strong emotions by juxtaposing the forces of life and death, of despair and hope. What does it say to you? To summarize your thoughts, try making a written record of your responses using the Visual Analysis Guide. Such an exercise usually reveals more than we realize about our reactions to a work of art.

Consider another painting, this time a very popular abstract work by Pablo Picasso from the Philadelphia Museum of Art, *Three Musicians* (Color Plate 2). More about identification—it's an oil on canvas, 80 × 74 inches, painted in 1921 in Fontainebleau, France, where Picasso lived and worked at the time. The subject matter is somewhat recognizable: three musicians are seated at a table reading from a musical manuscript. A harlequin plays a violin, a monk squeezes an accordion, and a masked man or woman in the middle toots a clarinet.

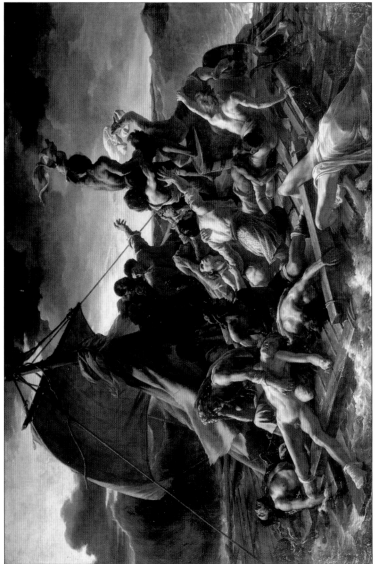

Color Plate 1 *Theodore Gericault (1791–1824): The Raft of the Medusa. 1819. Oil on canvas, 491 cm. × 716 cm. The Louvre, Paris.*

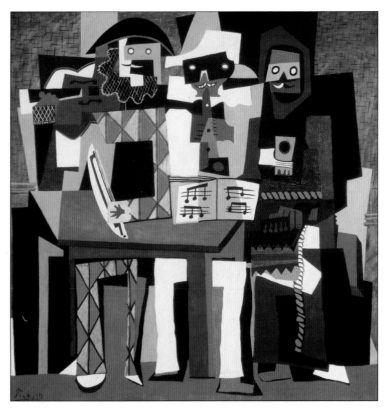

Color Plate 2 *Pablo Picasso:* Three Musicians *1921. 81 3/4 in. × 75 1/4 in.*
Philadelphia Museum of Art: A.E. Gallatin Collection.

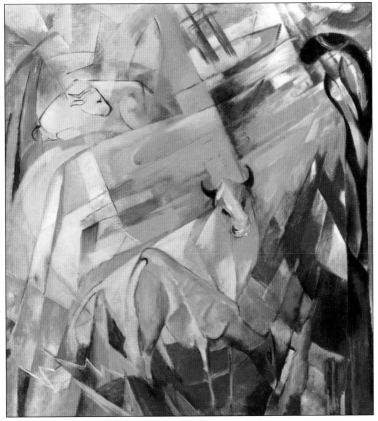

Color Plate 3 *Franz Marc (German, 1880–1916):* Animals in a Landscape. *1914. Oil on canvas, h 110.2 cm. w 99.7 cm. (Photograph © Detroit Institute of the Arts. Gift of Robert H. Tannahill. 56.144.)*

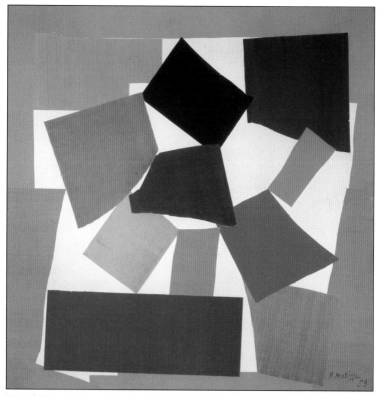

Color Plate 4 *Henri Matisse (1869–1954):* The Snail. *1953. Gouache on cut and pasted paper, 113 in. × 113 3/8 in. Tate Gallery, London, Great Britain. (Art Resource, NY.)*

Looking at the perceptual and formal characteristics in this work, we can easily follow the prominent lines created by the hard edges of figures which look as though they have been cut and pasted in the manner of a collage and locked together in a total pattern of shapes. This technique also produces a rough visual texture through brilliant black and white contrasts. Except for the raw reds and yellows in the clown's outfit, Picasso's colors tend to be muted pastels and earth tones.

The three figures occupy nearly all the space on the picture plane. And since the shapes forming the figures are similar to the shapes of surrounding space, an interesting interplay of unity, variety, and visual motion results. Parallels between the visual movement and the repetitious rhythms of music then become apparent. Another unifying device is the even distribution of selected colors, such as the light blue areas distributed at various places over the entire surface of the canvas which, in effect, help bring the total composition together.

The cultural context is the 1920s, which featured the new American craze in music: jazz, especially popular in France. (And apparently, even for those who played violin and accordion.) The arrangement of contrasting, hard-edged shapes reflects the strong, hard-edged beat of jazz. The bold rhythms of this new music are also related to the cut-and-paste look which Picasso pioneered during his Cubist period.

Another version of this work by the same title and painted at about the same time shows that the harlequin and the clarinet player have traded places. All three figures are still seated at a table, but this time a dog with upturned tail lurks beneath. What could that mean? You can find this work at the Museum of Modern Art in New York City.

Expressive qualities? Picasso obviously painted this picture with a great deal of pleasure, and that lighthearted spirit is conveyed to viewers. Quite the opposite expressive intent of Gericault! Picasso's blend of old subject matter and modern abstraction conveys a feeling of timeless delight.

TAKING NOTES AND SKETCHING

The best way to make the most of a museum visit is taking notes and making rough sketches of those works which most appeal to you. You may discover that certain pieces seem to leap out at you and grab your attention. If so, you want to remember as much about that experience as you can. Write down as much as you can on the spot, and make sketches, even if you feel you "can't draw a straight line." You'll be surprised how a quick scribble will be enough to recall the basic elements and structure of a work.

The very act of writing and sketching forces us to look more carefully and provides a surer way of learning about art than if we had merely glanced at it. If we write about art, we must examine it carefully and form some opinions about it, even if no one ever sees what we write or sketch. We can't sketch a work of art without taking a second or third look at it. The theory is that if we *write* clearly about an artwork, then maybe we have *seen* it clearly.

Taking notes in a museum is similar to sketching in that it helps you to remember salient points about particular works of art. In fact, notes can accompany your sketches to clarify your own observations and conclusions about the work. Note-taking is important in another way—as a preliminary stage in writing about art subsequent to the museum visit. It is therefore suggested that you jot down as many reactions to the work as you can; the more notes the better. In addition, notation of facts from the information sheets supplied by the museum will prove valuable for later use in writing an essay or report in your own words.

The Visual Analysis Guide will help you focus on various aspects of the work, but your own responses are most important. For example, Picasso's *Three Musicians* may strike you initially as a whimsical jigsaw puzzle or a patchwork quilt without meaning or artistic merit. Noting such a reaction, along with a few rough sketches, will help you recall your encounter with the work in the museum and may prove to be quite valuable if you decide to write about it later on.

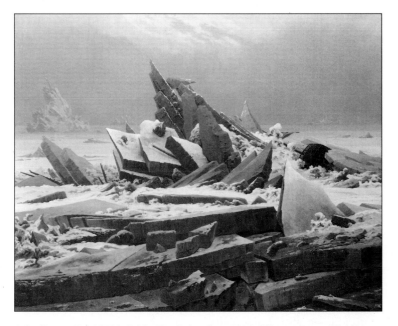

2.2 Caspar David Friedrich: The Polar Sea. *1824. Oil on canvas. 38 1/2 × 50 1/2 (97.7 × 50.3 cm). Hamburger Kunsthalle. (© Elke Walford, Hamburg.)*

Sketching and note-taking during museum visits are thus valuable for later reference. Your sketches will not be seen by anyone else, unless you choose to show them, and they don't have to be accurate replicas. Sketching is, after all, just another way of taking notes about a work of art.

The first step in making what artists call "thumbnail" sketches is to see an overall basic design of lines and shapes in the original. For example, if you were standing in front of the painting *The Polar Sea* by Caspar Friedrich (Fig. 2.2), imagine a framework of lines that would reduce the work to basic shapes (Fig. 2.3). This simple technique of first seeing the subject as a whole rather than its details is a natural way to begin seeing totally and not in fragments or separate parts. The objective is to become adept at *seeing parts in relation to the whole.* Most artists, including composers, poets, novelists, and architects, approach their work in this way.

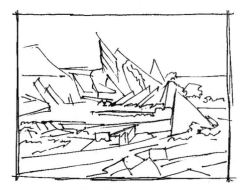

SKETCHING IN VALUE AND COLOR You have no doubt noticed that parts of an artwork are sometimes light or dark—even those in color. It is almost impossible to visit an art museum and not be surrounded with vivid, captivating color.

2.3 Sketch of The Polar Sea.

Color appears in everything: paintings, sculpture, photographs, artworks made with neon lights, fiber, wood, plastic, or clay, to name only a few. While you can't always take the time to paint in a museum (you must have special permission to do this), you can use colored pencils to add another dimension to the thumbnail "memos" you will be collecting during your visits.

Objects in your sketch can take on a surprising degree of reality by adding subtle touches of value. For example, by filling some areas in the *Polar Sea* sketch with darker values, we can achieve a three-dimensional quality (Fig. 2.4).

A value scale ranging from light to dark in black and white can be seen in the chart. Practice making your own value scales in the blank sets of boxes. Start with the white box, allowing its value to be the paper itself. Vary the pressure of a soft lead pencil (4B or 6B) in the first row of boxes, then do the same with a single colored pencil (any color) in the next row by matching the value of the color with the corresponding black-and-white value above. These gradations are only five of a vast number available to you in both color and black and white.

Completing the row of empty boxes with values and color to match will test your powers of observation and skill in rendering such subtle gradations. But more important, you will be able to recognize that all spectrum colors in nature have a corresponding value. For example, select something around you and note its color. Then find the same color

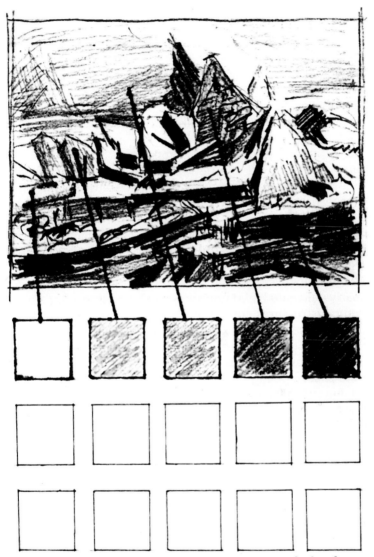

2.4 Sketch of The Polar Sea with areas shaded in a range of values from light to dark. Complete the second row in pencil, light to dark, and the bottom row in a selected color, light to dark.

somewhere else in your field of vision. Compare their relative darker or lighter values. Variables could include natural or artificial light and its source and the surfaces of surrounding shapes. So, as the painter looks out across a green landscape, he or she will at once see the foliage and grass as having a matching color, but a different value on a scale from light to dark. Many value changes are possible with each color on your palette, especially with the addition of white or black.

Try making thumbnail sketches from artworks seen at home, in magazines and newspapers, or even the scene out your front window. The more you practice drawing before your visit, the more comfortable you will be with sketching in a museum.

A tip to remember as you make your drawings: Artists imagine space as having three levels—foreground, middleground, and background. In the painting by the Master of the Barberini Panels: *The Annunciation* (Fig. 3.9), these areas are clearly delineated: two figures occupy the foreground, architectural structures form the middleground, and the background is seen in the distance. If values are the same from foreground to shapes further in space, artists will change that value and sometimes the color to indicate overlapping of separate planes, giving the illusion of deep space. Of course, we must grant that some artists may not choose such a method in achieving their objective with the subject matter.

SKETCHING TEXTURES The repetition of lines, dots, or shapes creates texture to offer yet another dimension to your drawing. Vincent van Gogh's *Starry Night* (Fig. 2.5) was painted with a series of short, heavy strokes using a brush loaded with thick paint which resulted in strong, rough visual textures. In fact, the paint was applied so heavily that, if the museum would allow us to touch the painting, we could feel the high and low places of the paint on the canvas—an example of tactile texture.

Various textures are possible with different media. Create texture with selected types of tools at your disposal. You will soon learn that each different tool produces a distinctive

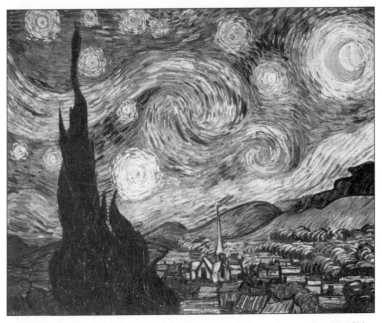

2.5 *Vincent van Gogh:* The Starry Night. *1889. Oil on canvas, 29 × 36 1/4 in.*
(73.7 × 92.1 cm). The Museum of Modern Art, New York.
(Acquired through the Lillie P. Bliss Bequest. Photograph © 1998 The
Museum of Modern Art, New York.)

2.6 *Vincent van Gogh:* The Starry Night *(detail). The texture in this*
painting can be achieved by repeating the lines represented by the artist's
thick application of paint.

texture; e.g., compare marks made with a pen and those made with a brush or charcoal.

Like most other endeavors, sketching improves with practice. Spend some time with simple exercises before embarking on your trip to a museum. It will prove to be time well spent.

THE MUSEUM VISIT

It has been clearly demonstrated that some form of activity carried on during a museum visit is far superior in terms of getting the most out of the experience. Participants in a study by the Getty Foundation on the museum experience indicated they were able to focus better on exhibits and thought more about what they were doing as a result of museum assignments.[1] A National Art Education Association anthology points out that adults on tours appreciate "an interactive approach to learning and will usually react favorably to well-chosen participatory activities or elaborating on a new or difficult concept."[2] Rather than being passive, museum-goers will profit most by observing closely and taking an active role in a meaningful interaction with art.

To that end, we have provided a series of exercises, or challenges, designed to be carried out in a museum during a visit. Some of them may seem a bit simplistic, and some may seem well beyond your interests or capabilities. The idea is to get involved with art by selecting those activities which are right for you. Each is divided into three parts: Purpose (why you should do this exercise), Preparation (how to get ready to do it), and Assignment (how to complete the exercise).

During your museum tour, assemble a record of whatever you see. Your sketches should include a record of artists' names, descriptions, titles, and the like. Collect ticket stubs and free brochures from the museum. Most museum gift shops sell art books, postcards, souvenirs, posters, and reproductions of the museum's permanent collection.

Take a camera with you. Most museums will allow photographs of their permanent collection if you agree not to use the flash. Be sure you use high-speed film for inside shots. We recommend using slide film so that images may be projected and viewed more closely to their actual size. Take a few pictures of your favorite works for later use as a resource for writing about art or creating your own art works. Try using your camera to capture the various angles in viewing sculpture in the round. Cameras are also useful as viewfinders to focus in on smaller areas of any work of art that strike you as particularly interesting.

Most major museums offer films or slide shows designed to introduce visitors to their permanent collections or to a special, temporary exhibition. We recommend that you make this your first stop; it's a great way to get an overview so that you can decide what area to focus on.

If you have never visited an art museum, you should simply wander about and slowly take it all in. Let the magic of the moment have its effect on you. Unless you are part of a tour group, there is no hurry—just take your time and *look*. Feel free to follow the path suggested by exhibit designers — chronological or hierarchical—because they have a definite logic and order which may prove to be important to you. When you begin to feel comfortable with where you are, go on to the challenges of the gallery exercises.

EXERCISE 1 LABELS

While some people feel wall labels are distracting, others feel the more you know about a work the closer you can come to a total aesthetic experience. This initial exercise is an attempt to provide some structure to your thinking—a way of getting started.

After wandering around, pause before an artwork that appeals to you but ignore the label. Record your reaction to the piece and make a quick sketch. Make specific notes about the subject, time period, medium, or whatever you wish so that, later on, this description will help to bring the work clearly to mind. Complete selected points from the rest of the Visual Analysis Guide. It is not necessary to respond to each and every question in the guide; some will not apply to every work. Compare your notes with those on the wall label.

Now, move to another work and begin by recording the information from the wall label. Continue with notes and sketches as you did with the previous work. Although these two approaches are quite different, both are valid, and you will find yourself using each method as you proceed on your visit. Record differences in the quality of the two experiences as you would in a casual conversation with a friend.

EXERCISE **2** **YOU NAME IT**

Was your choice of appealing works in the previous activities affected by the titles? Did they *have* titles? Amateurs and professionals alike end the process of making art with the task of assigning a title or some other means of identification. The purpose of this exercise is to understand the importance and impact of titles on viewer response.

Some works of art bear only a number, or perhaps the word *Untitled*. Hans Hofmann (1880–1966) has used such titles as "Blue Fantasy" or "Pink Dawn" for identification, but those titles have nothing to do with what you see in his paintings. They were developed in terms of formal elements alone, such as color, line, and texture, making representational titles inappropriate. On the other hand, many artists feel titles are an important part of the creative process and of the piece itself. They go to great lengths to make them thought-provoking or even obscure. An artist may select a title and then produce the work, while another may wait until the work is finished before naming it. It is now known that Jackson Pollock allowed his friends and acquaintances to name some of his paintings.

Richard Diebenkorn produced several works similar to that pictured in Fig. 1.7 and labeled them "Untitled." Viewers are likely to begin making up their own titles, thereby becoming more involved in the total process than they would if Diebenkorn had provided titles. Nonrepresentational works may not call for titles which refer to reality. The Diebenkorn piece could be called "Patterns in Black and White," but a designation like "Cityscape" or "Plowed Fields," on the other hand, could actually limit viewer response in not allowing a more personal interaction with the work.

Go ahead and provide your own title for the Diebenkorn, then search through the gallery for other works labeled "Untitled," or some other nondescriptive indication. Make up titles that tell more about what you see, describe your perception or feelings for the work, and why you chose the title.

EXERCISE **3** **F R A M E S A N D B A S E S**

One of the many benefits of visiting a museum is that you can see most paintings, drawings, prints, and photographs in their frames. The same is true for sculptures and their bases. Frames and bases seldom appear in catalogs of the museum's collection, or in art books. The purpose in calling your attention to frames and bases in museums is for you to become more attuned as to their effectiveness. Do these features make a difference in viewer response? Do they enhance the work's beauty or do they distract our view? Look again at Michelangelo's *Doni Tondo* (Fig. 1.5) and notice how the frame affects the painting in overall appearance.

Because they may be elaborate or simply too large, some frames are so overpowering that spectators have trouble concentrating on the artworks themselves. In the case of sculpture, the base may serve only as a foundation and therefore seem out of context with the work. Both frames and bases should complement the works they support.

Sculpture bases may have been a part of the original or added by museum officials in order to place the work at the most convenient level for viewing. Umberto Boccioni, in his *Unique Forms of Continuity in Space,* included two blocklike

structures as support for the person's legs (Fig. 3.1). However, another cast of the same sculpture at the Tate Museum appears with an additional slab connecting the two blocks (Fig. 3.2). Does this change the overall effect of the work in any way? Why do you suppose the slab was added?

Surprisingly, we may not actually notice frames and bases during a museum tour, which illustrates the craftsmanship of gifted curators and framers. Search for a painting in the museum that you feel is complemented by its frame. Then compare it with the unframed version in the museum catalog or a postcard of the work. Do the same thing with the base of a piece of sculpture. If you have a camera, take a picture of the works, and the comparisons can be made at a later date.

EXERCISE 4 IS BIGGER BETTER?

One reason why visiting museums is so exciting is that you can experience artworks exactly as the artists intended. Seldom are pictures of artworks in books or on posters shown in actual size. Many times a gigantic painting will appear to be the same size as a very tiny one. But in a museum the difference between the two is dramatic. At the Museum of Modern Art in New York City, three of Claude Monet's famous *Water Lilies* paintings are exhibited together. Each panel, as the paintings are called because they are the size of entire walls, is 6 feet 6 inches by 40 feet! The effect on visitors is one of virtual presence—we feel as if we are actually in Monet's garden. In this case, size or "scale," is a prominent factor in the aesthetic statement of the artist. The same principle applies to sculpture and all other works of art.

Search through the museum for a very large painting and write your response to the following questions: Does size have anything to do with a painting's aesthetic worth? Does size affect your feelings while looking at this large painting as compared with your reaction to smaller ones? Do you feel that the subject matter affected the artist's decision to make an artwork of such immense size, or could there have been other reasons? Imagine the painting in a very small format; would that change its impact?

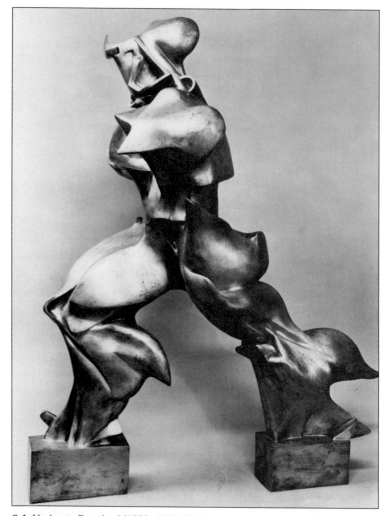

3.1 *Umberto Boccioni (1882–1916):* Unique Forms of Continuity in Space. *1913. Bronze (case 1931). 43 7/8 × 15 3/4" (111.2 × 88.5 cm). The Museum of Modern Art, New York. This version features two, separate blocks as the base. (Acquired through the Lillie P. Bliss Bequest. Photograph © The Museum of Modern Art, New York.)*

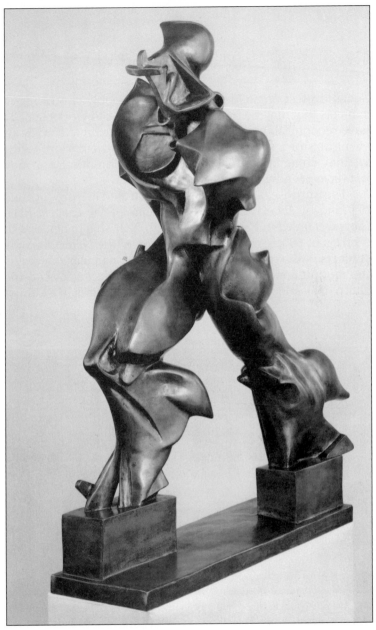

3.2 *Umberto Boccioni (1882–1916):* Unique Forms of Continuity in Space. *Tate Gallery, London, Great Britain. This version of the sculpture is the same as that found at MoMA in New York except for the base. Note the difference in overall effect. (Art Resource, NY.)*

EXERCISE 5 ART THAT TELLS
 A STORY

Social protest or political statements are only two of many subjects that may be found in museums. Such works usually have recognizable subjects and are often meant to convey an event or story. If we take time to analyze them thoroughly, we may come up with a valid interpretation; it may or may not have been what the artist intended.

The purpose of this exercise is illustrated in a provocative painting by Jacob Lawrence titled *One of the Largest Race Riots Occurred In East St. Louis* (Fig. 3.3). This panel, one of a series of 60 known as *The Migration of the Negro,* depicts subjects in the midst of a real event. Of particular interest is the motion and energy felt in the way the artist placed the sharp dark and light contrasting abstract figures in a kind of

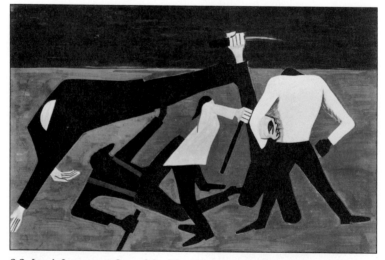

3.3 Jacob Lawrence: One of the Most Violent Race Riots Occurred in East St. Louis. *Panel 52 from* The Migration Series. *(1940–41; text and title revised by the artist, 1993). Tempera on gesso on composition board, 12 × 18″ (30.5 × 45.7 cm). The Museum of Modern Art, New York. (Gift of Mrs. David M. Levy. Photograph © The Museum of Modern Art, New York.) Some works of art tell a story.*

rhythmic alternation. The resulting interplay of angular shapes and surrounding space adds movement and energy which serve to heighten the drama.

Find a painting or sculpture in the museum containing subject matter that tells a story. Make a series of notes from the work as well as a quick sketch to anchor it in your memory. The ultimate objective is to transform these notes into a play or short story. The challenge is to use the characters or subject of the artwork in telling your own story.

EXERCISE 6 UNAPPEALING ART

This exercise may seem to be a bit hard to take, but it will test your powers of observation.

Find a work that you don't like and examine it for at least five minutes. Instead of dwelling on reasons why this particular work doesn't appeal to you, concentrate on its formal characteristics (especially if the subject matter is objectionable) and what they express rather than why you don't like it.

Record your observations about its possible **content** (meaning) along with notations about selected elements such as the work's linear configuration, use of color, and texture; then sketch the basic structure of the composition. This should help you in searching for possible reasons as to why this particular artwork is hanging in a museum.

EXERCISE 7 NUDES

One of the things that most first-time museum-goers discover is the proliferation of nudes as subjects for all forms of artistic expression. There's something about a nude that we all find fascinating. Artists since ancient times have used the unclothed human figure more than any other as an enduring object. What is it about the nude body that interests artists? Could it be the universal erotic appeal it holds for viewers? The human sexual instinct is universal, and a figure undressed provokes some degree of erotic charge automatically. Classical nude statues in the Vatican Museum have fig

3.4 Venus Capitolina. *Musei Capitolini, Rome, Italy. 4th century B. C. Marble. h. 6ft. 4in. Roman copy of a Greek original. (S0107728 K41305. Scala/Art Resource, NY.)*

leaves covering the genitals—an obvious attempt to deemphasize erotic connotations. On the other hand, artists must also be interested in the challenge nudes pose in their seemingly limitless potential for aesthetic expression. The challenge for viewers is to discover the many approaches artists take in the use of the nude for all kinds of art.

Compare the difference in erotic appeal as well as the aesthetic appeal between the ancient Roman work, *Venus Capitolina* (Fig. 3.4) and Marcel Duchamp's (1887–1968) highly abstracted painting *Nude Descending a Staircase* (Fig. 3.5). Where the Roman statue portrays the female form in graceful, sensuous detail, Duchamp used the nude body only as a vehicle to express the action of a figure in motion. The subject in the statue is a body; the subject in the Duchamp is about the motion of a body.

Search the museum for at least two examples of nudes of various styles and media and make some notes and sketches that

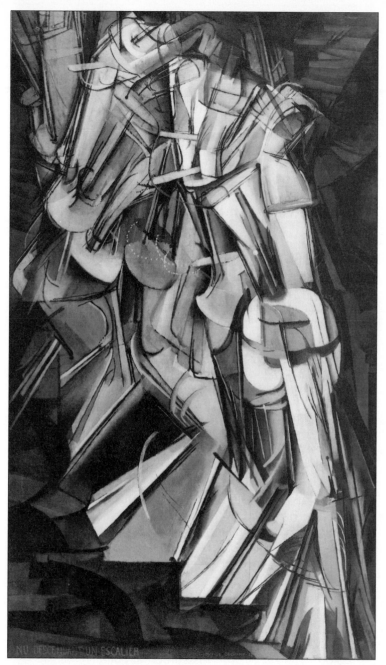

3.5 *Marcel Duchamp:* Nude Descending a Staircase, No. 2. *1912. Oil on canvas. 5′ 8″ × 35″ (147.3 × 89 cm). Philadelphia Museum of Art: Louise and Walter Arensberg Collection.*

address their differences and similarities. In your notes, point out the varying impact of style on erotic appeal to viewers. Mention also the effects of media on visual effectiveness of the works.

The purpose of this activity is to gain a clearer understanding of the relationship between art and music and also to enhance the appreciation of works in each discipline.

Any number of people have reported that they sometimes hear music when viewing a particular painting or sculpture. Others claim they see colors upon hearing certain passages of music. For most of us, the experience of comparing art to music takes place on a more practical plane. That is, we can visualize the way elements are presented in music if they seem to mirror those of a work of art. For example, Claude Debussy's (1862–1918) style of composing with muted orchestral colors is similar to Claude Monet's (1840–1926) pastel colors; Debussy's unresolved dissonances and fragmented melodic lines are similar to Monet's hazy atmospheric effects and short, divided brush strokes. Comparisons with other composers and artists also come to mind—J. S. Bach and Peter Paul Rubens; Ferdinand Delacroix and Franz Liszt; Pablo Picasso and Igor Stravinsky.

Many of the qualities and elements in music parallel those in the visual arts. Melody in music is akin to line in art; loud and soft contrasts in music are like dark and light contrasts in art; and dissonance in music is much like **abstraction** in art. Other parallel elements in art and music may also be considered:

Art	Music
volume and space	sound and silence
rhythm—repetition	rhythm—repetition
color	instrumental color
texture	thick and thin orchestration

Search for an abstract painting or sculpture and, while analyzing it for a few minutes, imagine some type of music that would provide an appropriate accompaniment. Picasso's *Three Musicians* (see Color Plate 2) is a natural; the paroxysmal motion implied in the interaction of shapes in space correspond to the syncopated way jazz moves through time.

Comparing works across the two disciplines can serve to enhance the aesthetic experience with each. If you have a Walkman and two cassettes of different types of music, take them along. Select two artworks of any style and match them with the two pieces of music. Write your responses to these match-ups in terms of how they reflect the music and make a quick sketch of the art work for later reference.

EXERCISE **9** **UNDERSTANDING THE ELEMENTS**

In some paintings and sculpture, artists use a dominant element to act as an expressive force for the entire composition. This can be seen in Lichtenstein's *Bull Profile Series* (see Fig. 1.9), where changes in value, linear treatment, shapes and their placement in space play important roles in the final resolution of the series. German Expressionist painter Franz Marc (1880–1916) used pure primary colors in a luminescent vision of animals in nature unspoiled by the presence of humans (Color Plate 3). The dominance of the element of color in its most intense treatment, complemented by the Cubist rendering of forms, provides the painting with a unique compositional unity.

Some works reveal a dominance of two or more elements in friendly contention—each providing a foil for the other. We have already seen an example of this interaction in the new entrance to the Louvre (see Fig. 1.3). Notice the angular repetition of lines and shapes in Pei's pyramidal structure compared to the more lyrical lines in the old buildings. The interplay of forces would be lost if Pei had used a linear treatment similar to that of the existing architecture.

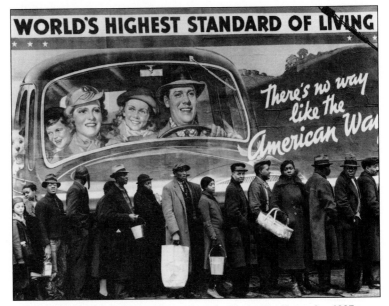

3.6 Margaret Bourke-White: Flood Victims, Louisville, Kentucky, 1937. *Photograph. (*Life Magazine*: Time Inc.)*

Find a work in your museum that features a dominant element and describe what the artist has expressed with that element. Make a sketch of the work selected, emphasizing the dominant art element. Then, make another sketch of the same work emphasizing a different element and compare your results. Examples include using intense primary colors on a sketch of Lichtenstein's *Bull Profile Series,* or rendering Marc's *Animals in a Landscape* with only lines.

EXERCISE **10** **THE FOURTH ESTATE**

In addition to their aesthetic beauty, artworks sometimes reflect a journalistic treatment of societal events that occurred during the working period of the artist.

Photographer Margaret Bourke-White combined art with social comment in her *Flood Victims, Louisville, Kentucky, 1937* (Fig. 3.6). The artist recounts the way the provocative photograph came about: she was simply driving along looking for subjects surrounding a flood that occurred in Louisville, Kentucky, in 1937. Suddenly, she saw a line of flood victims waiting for supplies and was startled by the contrast of the billboard behind them. The photo tells a story much more profound than the flood disaster itself. Other examples include Gericault's *The Raft of the Medusa* (see Color Plate 1), Picasso's *Guernica,* and J.M.W. Turner's *Burning of the Houses of Parliament.*

Search for an example by a modern or contemporary artist, especially a photographer, who has created journalistic records of our time just as Bourke-White did. Write as many notes as you think necessary to research the event at a later date.

EXERCISE **11** S H A P I N G S P A C E

One major objective of the artist, and the purpose of this exercise, is to examine how to achieve a balance between solid forms and surrounding space. The shapes of space in a composition are considered by artists as workable and coherent forms equal in importance to objects. In other words, whether the work is realistic or abstract, there is no such thing as left-over space. Whether intentionally or intuitively, all artists are aware of the interplay of solids and voids, of figure and ground. As viewers, we need to be aware of this balance between solid forms and the shapes of surrounding space.

The Chinese scroll, *Swallow and Lotus* (Fig. 3.7), reveals the skill of the artist in attaining a delicate balance between forms and space. And even with a representational subject, this painting could be somewhat abstract to those unaccustomed to seeing that much empty space. The bird occupying a tiny position in the large open area is critical in achieving this balance. Place your finger over the swallow and observe how the balance is affected: were it not for the bird, the space would overpower the solid forms in the lower left-hand corner.

Compare the treatment of space in Tanguy's abstract work, *Mama, Papa Is Wounded!* (Fig. 3.8) with that of *Swallow and Lotus*. Even without familiar subject matter, we can sense the balance of forces between solid forms and open space. In fact, all art forms rely on this balance of forces. Sculptors also deal with space—look at Henry Moore's *Reclining Figure* (see Fig. 3.11) and take special notice of the way he integrated the open spaces (holes, in this case) with the solid form.

Locate similar works in the museum and notice how space interacts with other forces to become an effective part of the total composition. Choose one of these paintings or sculpture to sketch and be aware of the shapes of space as you work.

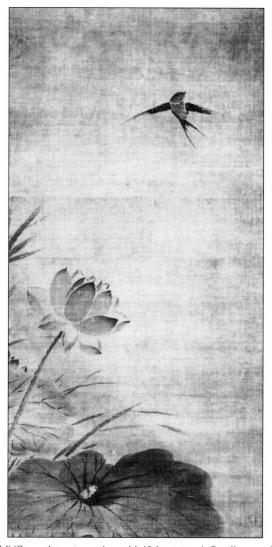

3.7 *Mu Ch'i (Song dynasty, active mid-13th century):* Swallow and Lotus. *Hanging scroll, ink on silk, 91.8 × 47 cm. The effect of open space is altered with the addition of the small bird form, which balances the total composition. (© The Cleveland Museum of Art, 1989, Purchase from the J. H. Wade Fund, 1981.34.)*

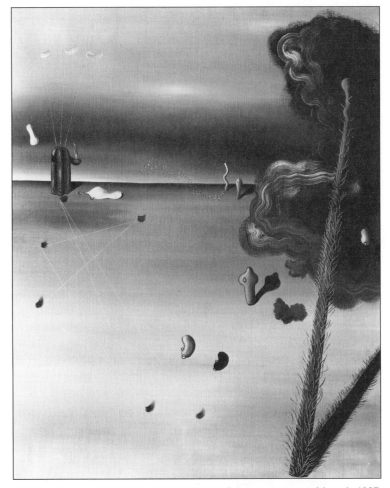

3.8 *Yves Tanguy:* Mama, Papa is Wounded (Maman, papa est blesse). *1927. Oil on canvas, 36 1/4 × 28 3/4″ (92.1 × 73cm). The Museum of Modern Art, New York. The effects of open space are similar in abstract paintings. (Purchase. Photograph © 1998 The Museum of Modern Art, New York.)*

During the Italian **Renaissance** (thirteenth to fifteenth centuries), artists refined and systematized the depiction of depth and distance on two-dimensional surfaces with a technique known as **linear perspective** in which all imaginary lines converge on selected points on the horizon. Our purpose in this exercise is to discover how this basic principle is accomplished.

The Annunciation (Fig. 3.9) by the Master of the Barberini Panels (c.1450) is an example of one-point perspective in which all lines leading into the distance seemingly converge at one point on the horizon, in this case, located beyond the archway just above the angel's head (Fig. 3.10). If we were able to move left or right of this scene to view buildings or other man-made objects, also with lines parallel to one another, we would see the illusion of other vanishing points on the same horizon—**two-point,** three-point perspective, or more with a wide-angle view.

Select one or two works from the exhibit that achieve an illusion of three-dimensional space. Make a list of the techniques the artist used to achieve depth, including overlapping shapes and making objects smaller and hazy in the distance (called **atmospheric perspective**). Compare works from various historical period styles and note the differences in how space is defined. Now, find a painting in which linear perspective is an obvious feature. Sketch some of the lines that lead to a vanishing point on the horizon and fill in some of the vertical lines that give the picture its definition.

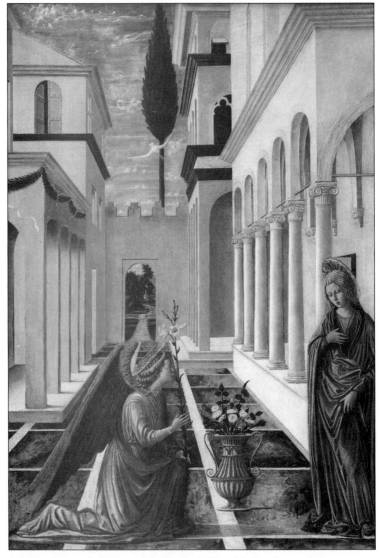

3.9 *Fra Carnevale (Master of the Barberini Panels):* The Annunciation. *c. 1448. Tempera (and possibly oil) on panel, .876 × .629 (34 1/2 × 24 3/4); framed: 1.200 × .924 × .083 (47 1/4 × 36 3/8 × 3 1/4). (Samuel H. Kress Collection, copyright Board of Trustees, National Gallery of Art, Washington, Photograph © Board of Trustees, National Gallery of Art, Washington, D.C.)*

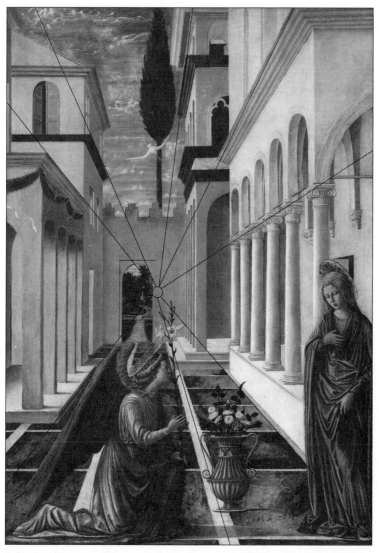

3.10 *Fra Carnevale (Master of the Barberini Panels):* The Annunciation. *Imaginary lines along the edges of the roofs, columns, curbs and the designs in the street appear to converge at a single point on the horizon. (Samuel H. Kress Collection, Photograph © Board of Trustees, National Gallery of Art, Washington, D.C.)*

EXERCISE **13** MOTION AND CHANGE

Our purpose here is to discover and experience one impor-
tant task facing sculptors working with solid forms and the
shape of surrounding space.

Like the Henry Moore work pictured in Fig. 3.11 or the
Calder in Fig. 1.6, most of the sculptures in any museum will
look different as you walk around them. Contours of each
shape change as they come into view and then disappear;
forms overlap others; holes open and close; and space sur-
rounding solid forms takes on added significance. These vi-
sual changes are all the more obvious in the Calder mobile
because the sculpture itself moves.

Search for a piece of sculpture that appeals to you and
sketch or photograph it from at least three sides. Some of the
problems and concerns of the sculptor as he or she worked
may be revealed to you as you move around the work. The
next time you have a soft, pliable claylike material in your
hands, cut, bend, twist, and stick it into shapes and look at
your result by following successive silhouettes—the way you
approached the museum works. This will give you an idea of
how it feels working in a full, 360-degree dimension.

EXERCISE **14** **PORTRAITS**

Most portraits in museum collections are more than simply
pictures of people. For this exercise, we will be looking for
portraits and identifying their expressive qualities.

Using various techniques, artists usually try to express
something beyond the obvious: to capture perceived charac-
teristics of the subject that a photograph may not. Vincent
van Gogh's self-portraits reveal the artist's troubled spirit
through the use of strong, heavy linear treatment and in-
tense hues. Late in his life, he painted himself with a bandage
over his partially severed ear, probably indicating that he
had come to grips with his mental illness and was able to deal
with it openly. Rembrandt's serene self-portraits seem to
glow against dark backgrounds as if to express hope in an
otherwise dark, dismal world. Both artists painted their own

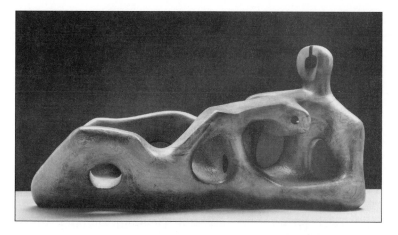

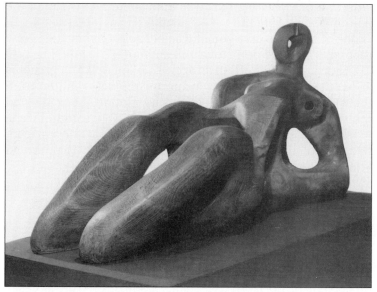

3.11 Henry Moore *(English, 1898–1986)*: Reclining Figure *(two views).*
1939. Elmwood, h 94, w 200.7, d 76.2 cm. As viewers walk around
sculpture-in-the-round, they notice a variety of forms as holes open and
close and as shapes overlap one another. (Founders Society Purchase with
funds from the Dexter M. Ferry, Jr. Trustee Corporation. Photography
© 1998 The Detroit Institute of Arts. 65.108.)

image over a broad period of their working lives, leaving us with a kind of autobiographical record. If the museum has more than one self-portrait of a given artist in its collection, you may wish to compare the changes wrought by time on the subject.

Mexican artist Frida Kahlo (1907–1954) also developed an autobiographical record with self-portraits, leading to a worldwide following for her distinctive body of work. Her paintings incorporate symbolic images rooted in her physical and spiritual suffering. Her provocative style of portraiture can be seen in her *Self-Portrait with Cropped Hair* (Fig. 3.12). The painting shows a defiant Frida holding a pair of scissors and surrounded by her own shorn hair, despite the admonitions of her husband, artist Diego Rivera (1886–1957) who thought her long hair was appealing. At the top of the painting she wrote the melody and lyrics of a popular song: "Look, if I used to love you, it was because of your hair, Now that you're bald, I don't love you anymore."

Search for portraits in all art forms. Jot down a few notes about the wide range of style and techniques, ranging from the most realistic to abstract representation. Look beyond the subject and think about the content, or meaning, of the work. Also, speculate on which artist seen at the museum you would choose to create your own portrait. How would you want to be portrayed?

EXERCISE **15**	STILL LIFES, LANDSCAPES, AND SEASCAPES

These subjects are popular among artists partly because the placement of horizon, trees, rocks, ships, or fruit is easily changed to achieve a variety of effects. They are also favorites among many spectators who feel more at home with familiar objects rather than more conceptual themes. In this exercise we can, in a sense, follow the way artists go about putting together a composition.

As an example, van Gogh arranged the objects in his painting *Starry Night* (see Fig. 2.5) with an enlarged cypress

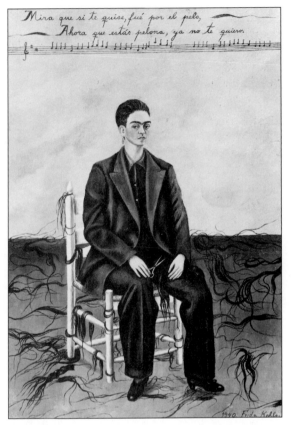

3.12 *Frida Kahlo:* Self-Portrait with Cropped Hair. *1940. Oil on canvas, 15 3/4 × 11″ (40 × 27.9 cm). The Museum of Modern Art, New York. (Gift of Edgar Kaufmann, Jr. Photograph © 1999 The Museum of Modern Art, New York.)*

in the foreground, providing a path of vision into the painting. Once there, the eye follows the exaggerated cloud shapes rolling across the top of the canvas and back down to the middle ground. Paul Cezanne, in his still life *Basket of Apples* (Fig. 3.13) created a virtual center of interest with his placement of objects, focusing our attention on the central area of the composition.

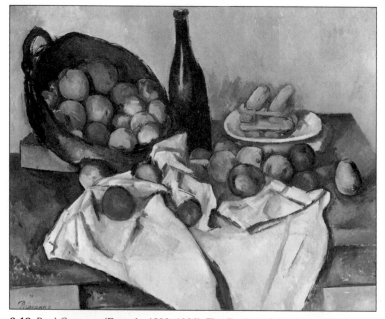

3.13 Paul Cezanne (French, 1839–1906): The Basket of Apples. *c. 1895, oil on canvas, 65.5 × 81.3 cm. In still lifes, artists have the freedom to arrange objects in the composition to suit their tastes. (Helen Birch Bartlett Memorial Collection, 1926.252. Photograph ©1999, The Art Institute of Chicago, All rights reserved.)*

Find a still life, landscape, or seascape in your museum and do a thumbnail sketch, but add or delete one prominent area of the original. Imagine how deleting the large tree in *Starry Night* or the wine bottle in *Basket of Apples* would affect the works' overall compositions. One could also add more trees to van Gogh's painting, or another wine bottle to the Cezanne. Such alterations would help us see how important each part of the painting is to the total work.

EXERCISE **16** **ART AND RELIGION**

The purpose of this part of the visit will be to discover the relationship between art and religion.

Religious subjects have been used as inspiration in all kinds of art from all cultures—in some cases for artistic expression alone and in others to enhance the ceremony of worship. Whether by inspiration or outright patronage from the church, artists have produced religious works in all forms of the visual arts. Various depictions of Christ on the cross, for example, reveal qualities and features which make each work unique among many on the same subject. Shapes forming the fourteenth-century sculpture *Corpus* (Fig. 3.14) were crafted with a directness thought by many to be possible only with the swift brush of the painter. The simplicity

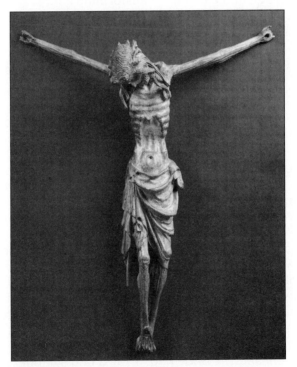

3.14 Corpus. (Crucified Christ.) *Germany, Middle Rhenish (Cologne). 1380–90. Walnut: 41.5 × 36.8 cm. (© The Cleveland Museum of Art, 1999, Andrew R. and Martha Holden Jennings Fund, 1981.52.)*

and unstudied look of the crucifix is misleading since we would assume that the lack of anatomical detail would mean a loss of expression and feeling obviously not the case in this figure.

Search for a work with a religious theme and include information in your notes as to its possible role in the society from which it came. This is especially important if the object is from a tribal society. Make a series of sketches developing some aspect of the subject into your own impression of the same theme. For example, if you were to sketch the *Corpus,* you might consider segmenting parts of the anatomy into more geometric shapes in the manner of a stained glass window. Actually, the very act of sketching a sculpture is a form of developing the theme—transforming a three-dimensional object into a two-dimensional work.

EXERCISE **17** **S Y M B O L S A N D I C O N S**

Throughout history, artists and artisans have used images to represent something intangible. In the museum, you are likely to find both **symbolism** and **iconography** used interchangeably; however, the latter term is most often associated with religious symbols. Symbolism can be found in the museum in one form or another, and that is our next objective: to search for symbols and attempt to determine their meaning.

We all know the most familiar examples: hearts mean love; dogs represent fidelity; doves bring peace; a lion is courage; and so on. In some cases, the artist includes a symbol which serves to identify the occupation or importance of the person in a portrait. To make your visit more fulfilling, you may find it useful to research the meaning behind symbols encountered in the museum. Their meaning can add a great deal to your enjoyment and understanding of a work of art.

In Jan van Eyck's (c.1390–1441) painting *Giovanni Arnolfini and His Bride* (Fig. 3.15), a dog symbolizes marital fidelity and the single candle burning in the chandelier may mean the presence of a deity or perhaps the fire of love.

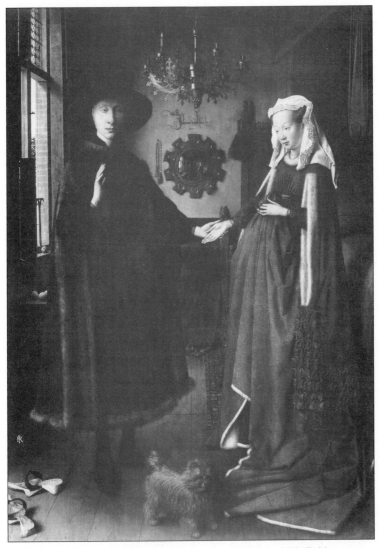

3.15 Jan van Eyck (c.1390–1441): Giovanni Arnolfini and His Bride.
*National Gallery, London, Great Britain. Search for symbols among various
objects in the painting and try to determine their meaning. (Alinari/Art
Resource, NY.)*

Rosary beads hang beside a mirror which is framed with scenes from the passion of Christ. Fruit on the window sill could stand for a "fruitful" marriage.

At the next exhibit, examine paintings and sculpture that include symbolic subject matter and make sketches, taking special care to include the symbols. You may speculate as to their meaning on the spot, but it is highly recommended that you research your findings in order to arrive at a more precise interpretation of the works.

EXERCISE **18** **R E A C T I N G T O C U L T U R A L D I V E R S I T Y**

You will find that most of the artworks displayed in American museums are derived from Western European culture. Check the collection of your museum for Native American, African, Oceanic, Asiatic, and pre-Columbian art to name just a few other cultures. Our objective for this exercise is to develop a wide interest in the arts beyond Western traditions.

Just as artists in Western culture have used art as religious symbols, tribal societies used art objects for purposes beyond beauty. They found use in communion with the spirit world, in educating their children, or in dealing with the unknown. So, when we confront an art object from another culture that at first may seem strange to us, remember that it is not so different from our own tradition in terms of functionality as well as artistic merit. For example, the Southwest Native American tribes are famous for the Kachina dolls (kah chee nah) which were given as gifts to children during tribal ceremonies in order to educate them in the form and symbolic nature of supernatural spirits. The costumed wooden form in Figure 3.16 is a stylized, basically geometric design. If you compare this piece with other works of art in this book from the European tradition, you will soon discover many similarities in terms of function, abstraction, decorative design, and principles of composition.

Locate a work from any non-Western culture and describe how it differs in terms of basic artistic principles like

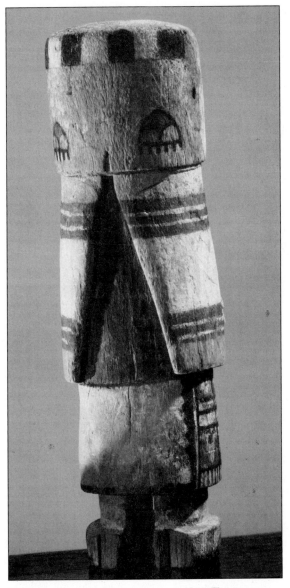

3.16 Kachina doll. *Hopi Indian, ca. 1850. The eyes represent the rain clouds and the lashes, rain. (Coll. Schindler, New York, N.Y., U.S.A. Werner Forman/Art Resource, New York.)*

65

medium, technique, color, and style (use the Visual Analysis Guide) from a selected work in the European tradition. Sketch each of the works side-by-side and take notes pointing out your observations.

EXERCISE **19** THE PICTURE WITHIN

Up to now, we have dealt with artworks as a whole—seeing as much as we could from an overall perspective. But there is also much to see *within* a painting or sculpture. By framing a small part of a work, we can concentrate on details which are often overlooked by the casual viewer. Our purpose here is to analyze a work of art by looking closely at a detailed section. In fact, artists call illustrations of small portions of a work a "detail." Examine the detail of van Gogh's *Starry Night* (Fig. 2.6) and consider it an independent artwork—a painting within a painting, so to speak.

With a camera, your fingers, or a view-finding device (like an empty 2×2 slide mount), select a small area in a painting or sculpture that looks like a complete work in itself. Make a sketch of the detail you discover, anticipating developing the sketch later on into your own version of the smaller composition. Note the relationship of the small area to the total composition. Does the total work now mean more to you than before you discovered the detail?

EXERCISE **20** A SCAVENGER HUNT

In addition to paintings and sculpture, most of the world's large museums collect a wide variety of works in various media ranging from fabrics to Renaissance salt cellars to contemporary videos of performance art. This activity is designed to focus your attention on all manner of objects in the museum's collection. In many cases, visitors are puzzled as to why museums would procure and display certain works as fine art. Why should we consider what was once a very functional teapot in the seventeenth century a work of art today?

For that matter, what objects around us at this very minute may become museum pieces in another century or two?

If you happen to be visiting the museum with friends, organize an informal scavenger hunt around a search for so-called "unconventional" art objects. Make a list of the types of art found and record information as to their historical period and ethnic origin. Referring to the Visual Analysis Guide, write a brief description of selected pieces in terms of their artistic qualities.

BRINGING THE
MUSEUM HOME

Throughout the preparations for your trip to the museum, you have been encouraged to keep a record of your visit by taking notes, making sketches, and taking home various items, such as catalogs, books, posters, and postcards of works in the exhibit. Now, in order to make the most of your experience, you should take the time to write about the art you saw and to make your own artworks based on your sketches and museum memorabilia. This material constitutes the basic resource for your writing, but it must first be organized into an outline that will serve its fundamental structure. Then, after you have assembled all you observed in your encounters with artworks, it is best to research the topic in order to verify and extend your notes. All this activity will result not only in a more satisfying and fulfilling museum visit, but future experience, particularly with the artist at hand, will be much more meaningful.

In his book, *Writing About Art,* Sylvan Barnet states, "We write about art in order to clarify and to account for our responses to works that interest or excite or frustrate us. In putting words on paper we have to take a second and third look at what is in front of us and what is within us. And so writing is a way of learning."[3] We do not so much write for

others as we do for ourselves; it is not the final *product* but rather the *process* of writing that is important because it constitutes a significant learning experience.

The same holds true for making your own art. Again, it is not the finished artwork but rather the act of creating it that will help you understand how artists produce their works and to better comprehend their meaning.

Writing about art and making art have much in common; each demands a reexamination and reconsideration of the subject. And, since any act of creating requires some sort of structure, both processes involve a series of steps that may be taken in the course of completing the task. Below is a partial list of these steps under their corresponding activity:

Writing about art

1. Decide on a concept or idea about the chosen artwork.
2. Analyze the work using the Visual Analysis Guide (taking notes).
3. Research the background of the work; e.g. artist and cultural context.
4. Organize information and make an outline to determine the scope and basic structure of the piece.
5. Begin writing by expanding the outline.
6. Revise (large alterations) and edit (make corrections).
7. Prepare the final draft.

Making art

1. Decide on a concept or idea to paint, draw, sculpt, etc.
2. Examine the subject very carefully and choose an appropriate medium.
3. Familiarize yourself with the subject; research the background if necessary.
4. Decide on composition with sketches; revise and refine the basic structure and size of the artwork.
5. Render the composition in the selected medium.
6. Change, modify, refine, and develop.
7. Begin final rendering of work and put on the finishing touches.

The actual processes of writing and creating art are il-
lustrated in Edgar Degas' (1834–1917) *Three Studies of a
Dancer in Fourth Position* (Fig. 4.1). Like writers, Degas be-
gan with a concept—in this case, he set out to sculpt a dancer
in fourth position. And, like the various stages in the prewrit-
ing process, Degas made a series of sketches from several
points of view. He was attempting to visualize the figure as it
would appear in three dimensions. The *Three Studies* can be
compared to the varying points of view discussed in Chapter
3, Exercise 13 on motion and change: look again at the Henry
Moore sculpture in Fig. 3.11.

Degas made at least sixteen sketches of his dancer as he,
like the writer, organized his information on the subject
at hand. Notice how the artist rethought portions of his

4.1 *Edgar Degas:* Three Studies of a Dancer in Fourth Position, *c. 1879/80.
Charcoal and pastel with stumping, with touches of brush and black wash,
on grayish-tan laid paper with blue fibers (discolored from pinkish-blue),
laid down on gray wove (pinkish-blue), 48 cm. × 61.5 cm. In these sketches,
the artist explored three views of the ultimate sculpture. (Bequest of Adele
R. Levy. The Art Institute of Chicago.)*

drawing—the figure on the right reveals several attempts at rendering the correct direction and proportion of the dancer's right leg. These redrawn sections correspond to rewriting, transposing, adding, and deleting passages in the process of writing.

The *Three Studies* shown here were made in the final stages of the artist's preparations, so these sketches closely resemble the actual bronze sculpture (titled *Statuette: Dressed Ballerina* at the Metropolitan Museum of Art, New York), which, incidentally, was adorned with human hair, a real gauze tutu and slippers.

MAKING ART

One of the most rewarding and beneficial activities in the process of learning about art is to make art. However, for those unaccustomed to creating their own art, this could prove to be somewhat intimidating. American painter Richard Diebenkorn once said that, in beginning a painting, we should attempt what is not certain. Most of us are hesitant to take chances unless we have a preconception of the final product. Degas was referring to a similar concept when he said, "Only when he no longer knows what he is doing does the painter do good things."[4] Both artists seemed to be implying that we all have natural feelings of inadequacy when challenged to complete an art project. The same applies to our first try at performing music, making a speech, or writing essays and poetry. Museum educator Alan Gartenhaus developed a working definition of creativity with several components: ". . . divergent thinking; open-mindedness to new ways of thinking regardless of what one is predisposed to believe; and an aim toward new understandings and change."[5] Keep in mind that we are not out to make great art; we are only using the process to gain a deeper understanding of what art is all about.

Most of the art activities suggested here require no special talents and nothing more than ordinary supplies that you may already own or are easily obtained. They need not be exotic or expensive; the quality of art media is secondary to their use in these exercises. Drawing tools include soft-

leaded pencils, **charcoal** sticks, and pastels (chalk or oil) along with a sketch pad. **Watercolors** and **acrylics** are recommended for painting, using appropriate brushes and watercolor paper. Some activities call for **mixed media,** a term which you may have encountered during your museum visit. It simply refers to the artists' use of more than one medium in a single work, like mixtures of **collage** and watercolor, or pastels and acrylics.

A word about drawing and painting: try not to think of painting as a more advanced skill than drawing, but rather different facets of the same process. Painting calls for special tools and media, but in the beginning stages of making art, you should think of painting as drawing in color. Drawing is usually thought to be the first step in a painting, followed by careful rendering within neatly drawn lines. Of course, some quick construction lines can act as a foundation for the painting's development, but you should try to use brush and pigment as freely as you would your pencil.

Collage is a relatively easy way to begin the process of making art. Various shapes and textures can be created by tearing or cutting painted paper, corrugated cardboard, tissue, magazine color, and even newspapers and old theater tickets. Rubber cement, glue sticks, or white glue will serve to hold the pieces together on a background of heavier stock. Look at Henri Matisse's *The Snail* (Color Plate 4) as an example; he cut and tore painted paper into large pieces and arranged them in the general shape of a snail. The result is an impressive and colorful work of art whose highly abstract subject can, with the help of the title, easily be discerned if you want it to be.

Many people find that working with three-dimensional artworks is more challenging than two-dimensional ones because they lack experience with it. However, we should think of sculpture as more than modeling clay or carving wood and marble; it also includes assembling and construction. The installation in Fig. 1.8 is a form of sculpture in that the artist assembled various parts and pieces into a coherent whole.

Three-dimensional art comprises most of the same elements used in drawing and painting, especially line, texture,

color, balance between shapes and space, unity, and so on. For our purposes, we do not need to carve from huge blocks of marble; we can construct interesting sculptures using blocks of wood, styrofoam, cardboard, and an infinite variety of found objects. One of Picasso's most famous sculptures is a bull made of the seat (head) and handlebars (horns) from an old bicycle. In another of his works, a toy automobile served as the head of a chimpanzee. Sculptor Louise Nevelson found hundreds of small wood bits, mounted them on solid surfaces, and painted many of them black. The result is a series of powerfully unified, nonrepresentative statements. These artists are telling us that the idea or concept of the artwork is more important than the sophistication of the materials used. For us viewers, it is also the process of putting the pieces together that provides insights as to how to look at sculpture.

Following are suggestions on writing and creating art, but they are by no means exhaustive. Feel free to search for your own solutions to questions and problems concerning your experience at the museum.

EXERCISE **1** **YOU NAME IT**

During your museum visit, Exercise 2 challenged you to find an untitled work and supply your own title in an effort to discover the influence of titles on the way we interpret content. Refer to your notes as you prepare to write an essay on the influence of titles on viewers' perception of art. A description of your interaction in the museum with "Untitled" works should provide you with a starting point.

With any drawing medium at your disposal, organize a series of lines, shapes, and textures into a nonrepresentational sketch which may or may not have meaning for you and give the result a title; or, ask someone else to supply a title for you. Think about the process of titling a work and how it affects the way you and others see it.

EXERCISE **2** **FRAMES AND BASES**

One of the duties of museum curators is to assess the quality of frames for two-dimensional works and bases for three-dimensional works. Sometimes, curators determine that original frames or bases do not complement the works and will construct more appropriate ones. If you participated in the activity dealing with frames and bases during your visit, you know how important these features are in how artworks appear to us on display.

It was suggested in Chapter 3 that you bring home a collection of posters, postcards, or even a museum catalog for later reference. If you took photographs of work in the museum, you can simply compare them with illustrations in a catalog or textbook, neither of which are likely to include frames or bases.

Attach the postcard or photo of a painting to a sheet of heavy paper or cardboard and sketch a frame around it that you feel would be the most pleasing aesthetically. It is surprising how even different colors in a frame can affect the way we perceive a painting. Write a paragraph or two about the effects of your artwork in its new "frame." If you use a picture of sculpture, you may have to cut around its contour in order to design a base which will complement the forms.

EXERCISE **3** **IS BIGGER BETTER?**

After looking at scores of illustrations in books or posters where it would appear that all artworks in museums are about the same size, most new museum-goers are unprepared for the stunning impact of scale alone. As you recall, it was suggested that taking slides of selected artworks would allow you to project and view images closer to actual size. If you refer to your recorded information regarding size of a projected artwork, you could move the projector

and screen closer or farther away until the proper proportions are reached.

During the visit you were asked to respond to the size of artworks and how that feature alone influences their aesthetic worth and your feelings about them. In the commercial world, large sizes of articles usually are more costly than smaller sizes. Does this apply to art in any way? What about the value of intimacy in miniature works? Try to answer these and other questions that occur to you on the effects of size in art.

EXERCISE **4** **ART THAT TELLS A STORY**

Recall your search for artworks that tell a story. From your notes and sketches, write a short story or play about your interpretation of the story depicted. You may proceed in either of two directions: research the background of the artist for the real story behind the work and tell it as accurately as you can, or you may allow your imagination and museum experience to lead the way in telling a story that may not be what the artist intended.

Reversing the situation, transform the essence or basic tone of a story, play, or movie into a drawing or painting. Don't attempt to paint an elaborate picture of the story; rather, use the basic elements to express an overall feeling about it.

EXERCISE **5** **NUDES**

It was suggested in Exercise 7 at the museum that you search for depictions of nudes in various styles and note their differences and similarities. You were asked to note the impact of style on erotic appeal as well as the effect of media. Write an assessment of those works you discovered, taking into account varying degrees of abstraction, differences between sculpture and painting, and historical period styles.

EXERCISE 6　　　　MUSIC HATH CHARMS

If you have slides taken during your museum visit, begin this activity by searching for examples of recorded music which correspond stylistically with the artworks. Project works of a particular period, such as **Impressionism** or **Expressionism,** while playing the music. The objective is to discover similarities across the two disciplines in terms of basic elements and principles, and also to gain insight as to the cultural milieu which fostered these developments.

Try drawing or painting while listening to music; mirror the mood and movement of the music in free linear patterns and colors. Write a rationale for your marks and colors as they relate to the music.

EXERCISE 7　　　　UNDERSTANDING THE ELEMENTS

Architectural examples in Chapter 1 illustrate how two architects used line, each with a different pattern of repetition, to establish a coherent unit. The intersecting diagonal lines in I. M. Pei's entrance to the Louvre (Fig. 1.3) differ significantly from the lyric quality of Frank O. Gehry's design of the Guggenheim in Bilbao, Spain (Fig. 1.2). But, in both, the dominant linear configuration provides the structures with a strong unifying force.

Write a brief essay on the importance of unity in any work of art—painting, sculpture, music, theater, dance, or cinema. If you discovered artworks during your visit that seemed to lack unity, comment on how that would affect the works' effectiveness.

During your visit, you were asked to take notes and sketches of a work featuring a dominant element. Then you were to make another sketch of the same work featuring a different dominant element. With those sketches as a point of departure, complete your own work of art as a drawing, painting, or a mixed media work. Try to maintain a unified statement in the composition with your choice of a new dominant element, such as line, color, and texture.

EXERCISE 8 THE FOURTH ESTATE

We learned in Chapter 3 that some artists, such as Margaret Bourke-White, can make art with a camera. With camera in hand, begin a search for a subject that you feel would qualify as photo journalism; e.g., automobile accidents, playground scenes, sports events, the homeless, the rich, or just ordinary people in their daily pursuits. After developing your prints, write a critique covering the event depicted in your photos. For Bourke-White, the title itself, plus the message on the billboard, was enough to make a meaningful statement.

EXERCISE 9 SHAPING SPACE

The shape of space in painting and other two-dimensional media is comparable to the negative space in a sculptural form. If you were to visit the Detroit Institute of Arts and walk around Moore's *Reclining Figure* (Fig. 3.11), you would see open areas in the sculpture change their shape. Artists are aware of these shapes of space in painting and drawing as integral parts of their compositions.

The sketches you made in Exercise 11 at the museum were to have included the open areas of space in a painting or drawing. Transform one of these sketches into a three-dimensional version of the composition using found objects such as styrofoam, scrap pieces of wood, and papier-mache.

In order to provide visitors with a more in-depth experience, museums will often include descriptive cards with sculptures describing processes the artist used and how the work was accomplished. Write such a descriptive card to accompany your own sculpture.

EXERCISE 10 A NEW PERSPECTIVE

During your museum visit, you were asked to compare a number of works to observe how artists achieve the illusion of three-dimensional space on a two-dimensional surface.

You should have discovered that such an illusion is accomplished in a number of different ways—linear perspective, overlapping shapes, and objects in the distance are smaller, closer together, and hazy. To learn more about these effects, research the principle of linear perspective and how it was perfected during the Italian Renaissance. Write a brief essay summarizing this principle as preparation for the next activity.

Using your sketches of paintings in the museum using linear perspective, complete your own drawing or painting. Begin by selecting a vanishing point anywhere along the horizon and place objects in the composition accordingly. If you maintain vertical and horizontal lines while following imaginary lines along the contour of objects and shapes leading toward the vanishing point, your composition should emerge into a cohesive pattern.

EXERCISE **11** **A N O T H E R N E W
 P E R S P E C T I V E**

The twentieth century has witnessed a new treatment of space in painting. Take another look at Picasso's *Three Musicians* (Color Plate 2) and Duchamp's *Nude Descending a Staircase* (Fig. 3.5) in which the relationship of solids and voids, or positives and negatives, takes place more or less on the surface of the canvas rather than in illusions of deep space. This concept of "shallow space" can also be observed in Henri Matisse's (1869–1954) *The Snail* (Color Plate 4) which was achieved by his attaching cut and torn pieces of painted paper to a surface in a circular design which expresses the essence of a snail. In this work, relationships between solid shapes and surrounding space occur on the surface, close to the viewer.

From your collection of sketches, pictures, and other mementos from the museum, construct your own collage by cutting or tearing shapes from paper in black, grays, and white. Place the shapes in position temporarily on a cardboard surface before gluing them down, allowing you to move them about until the desirable composition is

52887888888888

achieved. After gluing the shapes in place, use charcoal and white chalk to add dark or light value changes and contrasts in selected areas of your artwork. The purpose of this exercise is to participate in the creation of space by overlapping shapes rather than the traditional means of Renaissance linear perspective.

Collage played a major role in the development of the Cubist movement early in the twentieth century. Research the works of Cubists Picasso, Braque, and Gris and write an essay on their treatment of three-dimensional objects in painting, drawing, and collage.

EXERCISE **12** **PORTRAITS**

During your visit to the portrait gallery at the museum, you were challenged to search for and make notes concerning works in diverse styles, both realistic and abstract. Write a brief essay on the effects of style and abstraction on portraiture. For example, you could speculate on the dramatic differences in the way women are portrayed by Renoir and Picasso. Name an artist to paint your portrait and explain how you want to be portrayed.

Draw or paint a self-portrait, but not necessarily a duplicate looking in a mirror or at a photograph. It may be realistic or abstract, but try to portray yourself as you think others see you or as you see yourself. This could be an image of your inner world comprising joys, sorrows, loneliness, or other intense feelings. Investigate the many self-portraits of Frida Kahlo (see Fig. 3.12) and study the various ways she expressed herself symbolically.

EXERCISE **13** **STILL LIFES, LANDSCAPES, AND SEASCAPES**

You should have in your sketch pad two drawings—one in which you have deleted a shape or object from an original in the museum. In the other, a shape or object was added to the

existing composition. To help resolve the questions of how such alterations affect the overall composition, develop a final version of your own in any medium from one of the two options above.

Write a critique of your work focusing on how the changes you made altered, for better or worse, the original composition.

EXERCISE **14** ART AND RELIGION

Many of the prominent churches and cathedrals in Europe display monumental paintings, frescoes, and sculptures that are integrated with the architecture of the edifice and are used to enhance the quality of worship. During your visit, you were encouraged to find a work with a religious theme, sketch it, and take notes regarding its possible role in the society from which it came. Develop a complete artwork of your own in any medium at least twice the size of your preliminary sketches.

From your notes and any research required to learn more about the relationship of art and religion, compare and contrast the use of art objects in worship between tribal societies and modern-day churches. This is a broad topic, so you would be advised to limit your search by focusing on only one or two artworks in each society. Despite seemingly vast differences between the two, you may be surprised at the many similarities you will find. For example, comparing two works, the *Kachina Doll* (Fig. 3.16) and the *Venus Capitolina* (Fig. 3.4), we see sharp contrasts: one is realistic, the other abstract; one is monumental, the other miniature. But we also realize that these objects have much in common: both are sculptures depicting the human form. In one, the sculptor portrayed an ancient mythical god and the other is a symbol of an ancestral spirit world. Also, each, in its own way, is a stylized rendition of the human figure that speaks idiomatically to each of the societies in which it was created. In your writing exercise, search for comparisons and contrasts such as these to delineate the unique qualities inherent in each work.

<u>EXERCISE **15**</u> **THE PICTURE WITHIN**

In this exercise, we will be dealing with your detailed sketch or photograph of a painting or sculpture. As we observed in the detail of van Gogh's *Starry Night* (Fig. 2.6), small areas of a work can sometimes be considered a complete and coherent composition in and of itself. Develop your sketch or photograph into your own version of the smaller composition but use a larger format. Don't try to duplicate the original detail; allow your rough sketch and imagination to lead the way toward a new end result.

We hope these thoughts and activities have made your museum experience with art more meaningful and enriched. The more visits you make, the better your interaction with the artworks will become. All of your efforts will serve to demystify the art appreciation process and add confidence and reassurance for the next time you come face to face with a great work of art. Our hope is that you have found at least one work on your visit that overwhelmed you and made you curious enough to return again and again so that museumgoing becomes a lifelong habit.

GLOSSARY

abstraction The modification of natural forms in order to emphasize their intrinsic qualities.

Abstract Expressionism A style of painting developed in the 1940s characterized by an emphasis on methods of unconventional application of paint. (See *action painting* and *color-field painting*.)

Acquisition A museum's procuring artworks through gifts and purchases.

acrylic Polymer emulsion pigments in which small particles of plastic resin are suspended in water.

action painting A method of painting associated with Abstract Expressionism which involves free brushstrokes or the application of paint by dripping or splattering.

additive sculpture Works which have been built up or constructed rather than carved or reduced from a solid mass. (See also *subtractive sculpture*.)

airbrush A precision paint sprayer held like a brush and used for subtle blending and shading effects.

alabaster A white or pink translucent stone favored by many sculptors because its softness allows detailed carving.

altarpiece A work of art, either painting or sculpture, placed above or behind an altar.

aquatint A process of etching areas rather than lines. A metal surface is coated with rosin in fine drops and etched by acid to create subtle tones unlike the sharp lines of an engraving tool.

armature A framework or core used by sculptors to support the buildup of outer materials which are too soft to stand alone.

Art Deco A sleek style of design popular during the 1920s and 1930s in Europe and America. It is characterized by art objects using many opulent materials, such as glass, chrome, and ivory.

Art Nouveau (noo voh) A style of art characterized by flowing, decorative, curvilinear forms, popular in the late nineteenth and early twentieth centuries.

Ash Can School A group of American painters who, around the turn of the twentieth century, concentrated on urban slums for their subject matter.

assemblage A type of sculpture resulting from the arrangement of three-dimensional pieces of found materials.

atmospheric perspective The manner in which artists achieve the illusion of depth in drawing or painting by making distant objects appear hazy and less distinct. (Also known as *aerial perspective.*)

Barbizon School A group of mid nineteenth-century French landscape painters who gathered at the village of Barbizon near Paris and worked out of doors. They were influential in the development of Impressionism.

Baroque A seventeenth-century style of western European art characterized by elaborate ornamentation, flamboyance, and strong emotional content.

Byzantine (biz' un teen) A style of art from the Byzantine Empire, founded by Constantine in A.D. 330 and continuing until mid-fifteenth century, rich in iconography and known for elaborate stylization of figures.

calligraphy The art of creating elegant strokes with a brush or pen, producing stylized line in writing and painting.

cartoon A detailed drawing which serves as a model for murals, frescoes, tapestries, mosaics, or stained glass windows. Currently, the cartoon has popular meaning in political or satirical drawings.

ceramics Art works produced by the process of firing clay in a kiln using a variety of temperatures.

charcoal Drawing instruments made of carbon.

Chance Art The random ordering of elements that results in a freely expressed artwork.

chiaroscuro (kee' ah row skoo' row) An Italian term for the use of light and dark to produce the illusion of three-dimensional form or space on a flat surface.

Classicism The style of ancient Greek art revived during the Renaissance and neoclassical periods and characterized by restraint, balance, and simplicity.

closed form (See *sculpture in the round.*)

collage A work of art created by pasting bits and pieces of paper, cloth, or wood onto a heavy support.

color-field painting A style associated with Abstract Expressionism which involves the application of paint in broad areas, allowing color alone to evoke an aesthetic response.

conceptual art A work of art in which the emphasis is on an idea or concept rather than the art object itself.

constructivism A form of sculpture influenced by the Cubists in which objects appear to have been built up rather than carved or modeled.

content The meaning, intent, or aesthetic message of a work of art (distinct from subject matter).

contrapposto The disposition of parts of the human figure to achieve a lifelike appearance. The axes of the hips and shoulders shift in opposite directions when the figure's weight is placed on one foot.

crosshatching The use of repetitive, crossed lines to depict shadow and three-dimensional shapes of value changes in an engraving, drawing, or painting. Hatching is achieved with parallel lines.

Cubism A style of art developed by Picasso and Braque in which natural forms are reduced to geometric units and reordered to present several points of view simultaneously.

Dada (dah dah) A style of art which began in the early twentieth century characterized by whimsical subject matter; intended to mock serious art and the society that espoused it.

daguerreotype An early photographic process developed in the nineteenth century by Louis Daguerre who showed that images appear on a silver-coated copper plate when exposed to light and treated with mercury vapor.

display The arrangement of art objects in an exhibit.

diptych (dip tik) Originally, two painted or carved panels, hinged so they could be folded. Now refers to any two-paneled work. (See also *triptych.*)

docent A person who acts as a museum guide for tours by individuals or groups.

Early Christian Art of many styles created by Christians from the third to sixth centuries, dominated by scriptural subject matter and Greco-Roman traditions.

encaustic A painting medium with a binder of wax mixed with pigment and applied while hot.

engraving A method of printing in which lines cut into the surface of a metal plate are filled with ink and pressed onto a paper surface.

environmental art Works conceived as integral parts of their intended surroundings.

etching A method of printing in which a metal plate is coated with resin, images are scratched through the coating, and covered with acid. The acid etches the metal exposed by the scratches and the resin is removed; ink is applied to the plate and pressed onto a paper surface.

Expressionism A style of art characterized by the depiction of the artist's feelings and subconscious world. Figures are often distorted and depict the dark side of human experience.

Fauvism (foh' vism) An art movement of the early twentieth century in which bold, intense color was used as the fundamental means of expression.

fetish An art object thought by tribal societies to possess magical powers strong enough to control nature.

figure-ground The relationship of forms and surrounding space.

focal point Generally used to describe the center of interest in a work of art.

foreshortening A system of drawing and painting in perspective to produce the illusion of projecting forms into space.

format The size and shape of a work of art, either rectangular, round, square, etc. The artist selects a proportion that best suits the subject or idea being expressed.

fresco A painting executed on wet, plastered surfaces that allows the paint to become part of the wall and ceiling by combining with the plaster upon drying. *Fresco secco,* or dry fresco, refers to painting on a wall where the plaster has dried, then wet with water at the time the paint is applied.

frieze The horizontal surface in architecture located below the pediment area and often used for decorative relief sculpture.

Futurism Title describing the work of a group of early twentieth-century artists who were dedicated to destroying past traditions and developing a new form of art characterized by violent motion and strong energy, often called the interpretation of speed.

frottage A technique of producing images by rubbing on paper placed over textured objects such as bas-reliefs and gravestones.

genre paintings (zhahn' ruh) Works that depict subject matter from everyday life.

gilding The process of applying extremely thin sheets of real gold leaf to cover wood or glass surfaces.

geometric abstraction The reduction of natural forms to simple, angular images resembling rectangles, squares, circles, cubes, triangles, cylinders, or irregular shapes.

gesso A liquid made from a mixture of chalk and glue and applied to canvas and wood as a painting surface for oil, acrylic, etc.

gesture The use of spontaneous line drawn or painted to express the essence of a subject—often what it is doing rather than what it looks like.

glaze A coating used by potters to create a glassy surface on clay pottery or ceramic products.

glazing A method of superimposing thin, transparent layers of paint to create interesting illusions of volume or depth in a painting.

Gothic A style of architecture and art in the late medieval period, from the twelfth to the early fifteenth centuries, characterized in church design by pointed arches and high-vaulted ceilings.

gouache (gwash) A water-soluble paint that dries opaque.

grisaille (gree zah' ee) A technique of painting in shades of gray.

hatching (See *crosshatching*.)

Hellenistic A style of Greek art of the third and second centuries B.C. characterized by dramatic images.

holography The technique producing projected, three-dimensional images with the use of lasers.

icon A symbolic image which often has religious meaning.

iconography The pictorial illustration of icons.

illumination A medieval practice of hand decorating elaborate designs in books and manuscripts.

impasto A thick application of paint, usually in layers, producing a roughly textured surface.

Impressionism A style of art that appeared in France in the last half of the nineteenth century characterized by the play of light on natural objects. The effects are often achieved by applying unmixed, intense hues with divided brushstrokes.

installation A work of art usually composed of many pieces and created in a museum setting intended to be viewed and experienced as a composite, as opposed to individual, paintings or objects. Today, installations are often permanent and called "site-specific."

intaglio (in tahl' yo) A process of printing in which lines are incised, or cut into, a hard surface. (See also *engraving* and *etching*.)

International Style A style of architecture, beginning in the 1920s, in which the support walls of structures were moved from the outside shell to the inside for greater flexibility of design. Buildings were usually without excessive ornamentation.

kinetic sculpture Artworks designed to move. (See *mobile*.)

lettrisme An art form first used in the twentieth century by the Cubists who added bits of newspaper or sheet music to a collage or painting surface. Art forms of the 1960s, using typography and other symbols, evolved into sophisticated painting and sculpture.

linear perspective A system of depicting the illusion of three-dimensional forms in deep space on a two-dimensional surface by causing parallel lines to converge on one or more vanishing points on the horizon.

lithography A method of printing in which images are drawn with an oil-based crayon, pencil, or liquid tusche on a flat surface—usually a limestone block. The surface is then wiped with water and rolled with greasy ink which adheres only to the parts drawn with the oil-based media. Dampened paper is pressed onto the stone, transferring the image from the stone to the covering sheet. (Also known as *planography*.)

lost wax A process of casting an image which has been modeled in wax. When heated, the wax is melted out of a mold, and molten metal (often bronze) is poured into the cavity left by the "lost" wax. (Synonym—*cire perdue;* Fr. for "lost wax.")

Mannerism A style of art from the late sixteenth and early seventeenth centuries characterized by individual affectations, such as elongated figures and distorted perspective.

Medieval A term applied to art of a long period of time, roughly the fifth to the fifteenth centuries, during which the Christian church permeated nearly every facet of the arts.

Minimalism A style of art in both sculpture and painting in which forms are reduced to simple linear, color, or geometric units.

mezzotint (met' zo tint) An engraving process in which areas on a metal plate are roughened to produce the realistic effects of light and shade.

mixed media The technique of using more than one medium, such as collage and watercolors, to produce a single work of art.

mobile Sculpture with moving parts set in motion by air currents or motors. (Also known as *kinetic sculpture.*)

monochromatic The use of only one hue—usually seen in varying degrees of value and intensity.

monotype A printing technique in which an image is painted on a solid surface and transferred to paper. Thus, only one print of a kind can be made.

mosaic Artworks in which small pieces of tile or glass are imbedded into mortar to form large patterns and images.

naive art A category of artworks produced by artists without professional training. Images are often frank and bold but lack realistic proportions and traditional refinements. (Also known as "folk art" due to its forthright depiction of everyday life.)

naturalism Refers to subject matter that closely resembles natural forms.

Neoclassicism A style of art from around the turn of the nineteenth century which revived the restrained purity of Greek and Roman antiquity and infused it with a pristine clarity of light and shadow.

Neo-Expressionism A style of art of the 1970s and 1980s, usually associated with German artists, which revived to some extent the expressionist style of pre-World War I Europe.

Neo-Plasticism A term coined by Piet Mondrian to describe his approach to painting in which reality is expressed in terms of rectilinear forms and primary hues.

nonobjective art (same as *nonrepresentational art*)

nonrepresentational art Works in which forms, lines, and colors are used for their own expressive qualities rather than any reference to reality. (Often called *nonobjective;* compare *abstraction.*)

Op Art A style of painting utilizing lines or colors in such a way that the eye senses motion. (Also called *Optical Art.*)

open form (See *sculpture in the round.*)

patina (pat' uh nuh) The color of bronze or other metal surfaces that results from oxidation of chemical treatment.

performance art That which is performed by live actors sometimes combining music, poetry, and painting before an audience and often does not involve a permanent work of art.

permanent collection A museum's holdings; that is, all of the art works it owns.

perspective (See *linear* and *atmospheric perspective.*)

Photorealism A style of art in which images appear so realistic that they resemble actual photographs.

pictorial space Space created on a two-dimensional surface by dividing the area into roughly three sections: near objects in the foreground (shallow space) and objects progressively farther away in the middle ground and background (deep space).

Planography (Same as *lithography.*)

Pointillism The technique of applying tiny dots of paint to the canvas to create forms and optical mixtures of color; e.g., tiny dots of red and yellow in close proximity would appear orange to viewers. (See late works by Georges Seurat.)

Pop Art A style of painting and sculpture associated with the period encompassing the 1950s through the 1970s, in which subject matter was derived from, and often parodied, popular culture.

porcelain A fine-grained, translucent chinaware fired at high temperatures to achieve high luster and delicacy.

post-Impressionism A style of art appearing in the last two decades of the nineteenth century inspired by the Impressionists' emphasis on light and color but characterized by bolder coloration, stronger formal elements, and expressive symbolism.

preservation Precautions taken by museum curators to ensure that artworks do not deteriorate or suffer damage.

print A term describing an impression made by a printing process. Multiple prints are usually identified in pencil at the bottom with the print number, title, artist's name, and date. The print number 10/20, for example, means the tenth impression from a total edition of 20.

ready-mades Works of art constructed of preexisting objects that assume new functions and meanings in the hands of an artist.

Realism A term most often used to describe the style of some nineteenth-century French artists whose subject matter was based on ordinary people and events. Also used to describe visual accuracy.

relief A basic printing process in which the designs of shapes and lines are raised above the plate or background. (See *woodcut*.)

Renaissance (ren' uh sahns) The period of European history spanning the fourteenth through the sixteenth centuries; characterized by a humanistic revival of classical antiquity in art, literature, and music.

representational A term used to describe subject matter that closely resembles the real world.

Rococo (roh coh coh) An eighteenth-century style of art that grew out of the Baroque and was characterized by elaborate, delicate ornamentation and frivolous subject matter.

Romanesque A medieval style of architecture, as well as painting and sculpture, influenced by the Romans and dating from roughly the ninth to the twelfth centuries; characterized by rounded arches and barrel vaults.

Romanticism The prevalent style of the first half of the nineteenth century, characterized by strong emotional content, turbulent activity, and heroic subject matter (as in Gericault's *The Raft of the Medusa*).

Salon The official annual exhibition of painting in nineteenth-century Paris; administered by a learned society of art critics.

Salon de Refuses (ray foo zay') The exhibit established in 1863 as a result of public outcry for the exhibition of those paintings "refused" by the nineteenth-century Salon Academy.

sculpture garden The outdoor display of a museum's sculpture collection.

sculpture in the round The phrase used to designate three-dimensional works that can be viewed from any angle (often referred to as "freestanding sculpture"). **Open form** refers to sculpture with an extension of parts into open space while **closed form** refers to work in which all parts touch and maintain most of the original size and shape of the medium.

serial painting A sequence of paintings advanced by Claude Monet in which the artist paints the same subject at different times of the day or seasons of the year in order to depict the varying effects of light.

serigraphy (See *silk screen.*)

silk screen A printmaking technique employing the use of stencils. Images are cut and attached to fine-mesh silk held by a frame. Printing ink is forced through the open areas of the stencil and deposited on paper, cloth, or other ground supports. (Also called *serigraphy.*)

silver point Refers to drawings made on paper with pencils made of silver. Aging causes the silver to darken to a warm tone.

stabile (stay′ beel) A stationary piece of constructive sculpture with no moving parts, as opposed to *mobile*. Usually refers to the abstract works of Alexander Calder who coined the term.

subtractive sculpture Works that have been carved or chiseled; that is, subtracted from a solid piece of material such as clay, marble, or wood. (See also *additive sculpture.*)

sunken relief A form of sculpture in which positive shapes are cut to a shallow depth, allowing negative space to stand out.

Super Realism A style of art developed in the 1960s and 1970s that represented natural subject matter with such highly detailed accuracy that some would call the paintings or sculpture photographic. (See also *Photorealism.*)

Surrealism A style of art that grew out of the Dada movement in the 1920s and was characterized by subject matter derived from the subconscious and by mysterious symbolism.

symbolism The representation of subjective ideas or meanings by using ambiguous elements and objects, in literature as well as the visual arts.

ART MUSEUMS IN
NORTH AMERICA *

This is simply a partial list of North American art museums. Please let us know if you have any suggestions for additions to this list.

Canada

Kleinburg, Ontario: McMichael Canadian Art Collection; (905) 893-1121 Website: www.mcmichael.on.ca

Montreal, Quebec: Montreal Museum of Fine Arts; 1379 Sherbrooke Street West, C.P. 3000, Succursale H (514) 285-1600; Website: www.mmfa.qc.ca

Ottawa, Ontario: National Gallery of Canada; 380 Sussex Drive, P.O. Box 427, Stn. A, KlN 9N4, (800) 319-2787 Website: http://national.gallery.ca

Toronto, Ontario: Art Gallery of Ontario; 317 Dundas Street West M5T 1G4 (416) 979-6648 Web site: www.ago.net

Toronto, Ontario: Royal Ontario Museum, 100 Queen's Park M5S 2C6 (416) 586-5549

Alabama

Birmingham: Birmingham Museum of Art; 2000 8th Ave. N. 35203 (205) 254-2565 fax (205) 254-2714 Web site: www.artsbma.org

Birmingham: University of Alabama at Birmingham Visual Arts Gallery; 900 13th St. S, UAB Station 35294-1260 (205) 934-4941, fax (205) 975-6639 Web site: www.main.uab.edu

Mobile: Mobile Museum of Art; 4850 Museum Dr. P.O. Box 8426 36689 (334) 343-2667

Tuscaloosa: University of Alabama Sarah Moody Gallery of Art; Box 87020, Garland Hall 35487-0270 (205) 348-1890 fax (205) 348-9642

Alaska

Anchorage: Anchorage Museum of History and Art; 121 W. Seventh Ave. 99501 (907) 343-4326 fax (907) 343-6149

Fairbanks: University of Alaska Museum; PO Box 756960 99775-6960 fax (907) 474-5469 Web site: www.uaf.alaska.edu/museum/

Juneau: Alaska State Museum; 395 Whittier; 99808 (907) 465-2901

Arizona

Flagstaff: Northern Arizona University Art Museum and Galleries; PO Box 6021 86011 (520) 523-3471 fax (520) 523-1424 Web site: www.nau.edu/art_museum

Phoenix: Phoenix Art Museum; 1625 N. Central Ave. 85004 (602) 257-1880 fax (602) 253-8662 E-mail: info@phxart.org Web site: www.phxart.org

Tempe: Arizona State University Art Museum; Nelson Fine Arts Center 85287 (602) 965-2787 Web site: http://asuam.fa.asu.edu/homepage.htm

Tucson: Tucson Museum of Art; 140 N. Main Ave. 85701 (602) 624-2333

Tucson: University of Arizona Museum of Art; Speedway and Park Ave. 85721 (520) 621-7968 Web site: http://artmuseum.arizona.edu/art.html

Arkansas

Fayetteville: University of Arkansas Fine Arts Center Gallery; 72701 (501) 443-9216 fax (501) 575-2062

Little Rock: The Arkansas Arts Center; MacArthur Park 72203 (501) 372-4000 fax (501) 375-8053

Little Rock: University of Arkansas at Little Rock University Galleries; 2801 S. University 72204 (501) 569-3182 fax (501) 569-8775 E-mail: sdmitchell@ualr.edu

California

Bakersfield: California State University, Bakersfield Todd Madigan Gallery; 9001 Stockdale Hwy 93311-1099 (805) 664-2244 fax (805) 665-6901 E-mail: mnowling@csubak.edu

Berkeley: University of California, Berkeley Art Museum and Pacific Film Archive; 2626 Bancroft Way 94720 (510) 642-0808 fax (510) 642-4889 Web site: www.bampfa.berkeley.edu/textonly.html

Davis: University of California, Davis Richard L. Nelson Gallery & The Fine Arts Collection; 124-125 Art Building 95916 (530) 752-8500 fax (530) 754-9112

Fresno: Fresno Art Museum; 2233 N. First St. 93703 (209) 441-4220 fax (209) 441-4227 E-mail: FAM@gnis.net

Irvine: University of California, Irvine The Art Gallery; 92697 (714) 824-8251 fax (714) 824-5297

La Jolla: Museum of Contemporary Art, San Diego 7000 Prospect St. 92037 (619) 454-3541 fax (619) 454-6985 Web site: www.mcasd.org

Los Angeles: J. Paul Getty Museum at The Getty Center; 1200 Getty Center Dr 90049-1681 (310) 440-7300 E-mail: cip@getty.edu Web site: www.getty.edu/museum

Los Angeles: Los Angeles County Museum; 5905 Wilshire Blvd. 90036 (213) 857-6111 Web site: www.lam.mus.ca.us/

Los Angeles: The Museum of African American Art; 4005 Crenshaw Blvd. 90008 (213) 294-7071

Los Angeles: University of California, Los Angeles Armand Hammer Museum of Art and Cultural Center; 10899 Wilshire Blvd 90024 (310) 443-7000

Los Angeles: University of Southern California Fisher Gallery; 823 Expositions Blvd. 90089-0292 (213) 740-4561 fax (213) 740-7676

Oakland: The Oakland Museum of California Art Division; 1000 Oak St. (510) 238-3005 fax (510) 238-6925 Web site: www.museumca.org

Pasadena: Art Center College of Design Alyce de Roulet Williamson Gallery; 1700 Lida St. 91103 (626) 396-2397 fax (626) 405-9104 E-mail: nowlin@artcenter.edu Web site: www.artcenter.edu/exhibit.williamson.html

Sacramento: Crocker Art Museum; 216 O St. 95814 (916) 449-5423 fax (916) 264-7372 E-mail: crocker@sacto.org Web site: www.sacto.org/crocker

San Diego: San Diego Museum of Art; 1450 El Prado, Balboa Park 92101 (619) 232-7931 Web site: www.sddt.com/sdma.html/

San Diego: San Diego State University Art Gallery; School of Art, Design and Art History 92182-4805 (619) 594-4941 fax (619) 594-1217 E-mail: artgallery@sdsu.edu Web site: www.sdsu.edu/artgallery

San Francisco: Asian Art Museum of San Francisco The Avery Brundage Collection; Golden Gate Park 94118 (415) 379-8800 fax (415) 668-8928 E-mail: info@asainart.org Web site: www.asianart.org

San Francisco: California Palace of the Legion of Honor Fine Arts Museums of San Francisco; Lincoln Park, 34th Ave & Clement St. 94121 (415) 863-3330 fax (415) 750-3656 E-mail: guestbook@famsf.org Web site: www.thinker.org

San Francisco: San Francisco Museum of Modern Art; 151 Third St. 94103 (415) 357-4000 TDD (415) 357-4154

San Jose: San Jose Museum of Art; 451 S. First St. 95113 (408) 283-8155 fax (408) 294-2977 E-mail: sjma@netgate.net Web site: www.sjmusart.org

San Jose: San Jose State University Thompson Art Gallery, School of Art and Design; Washington Square 95192-0089 (408) 924-4328 fax (408) 924-4326

Stanford: Stanford University Museum of Art and T. W. Stanford Art Gallery; Lomita Dr. and Museum Way 94305-5060 (650) 732-4177 Web site: www.stanford.edu/dept/ccva

Colorado

Boulder: University of Colorado at Boulder CU Art Galleries; Broadway, between 15th and 16th Sts. 80309 (303) 492-8300 fax (303) 492-4886

Denver: The Denver Art Museum; 100 W. 14th Ave. Parkway 80204 (303) 640-4433 Web site: www.denverartmuseum.org

Connecticut

Bridgeport: University of Bridgeport University Gallery, Arnold Berhard Arts & Humanities Center; University & Iranistan Aves. 06601-2449 (203) 576-4402 fax (203) 576-4051 E-mail artatub@aol.com

Hartford: Wadsworth Atheneum; 600 Main St. 06103 (860) 278-2670

New Haven: Yale University Art Gallery; 1111 Chapel St. 06520 (203) 432-0600 Web site: www.cis.yale.edu/artgallery

Stamford: Stamford Museum and Nature Center Leonhardt Galleries; 39 Scofieldtown Rd. 06903 (203) 322-1646 fax (230) 322-0408 E-mail: amnce@ix.netcom.com Web site: www.stamfordmuseum.org

Delaware

Newark: University of Delaware University Gallery; 114 Old College 19716-2509 (302) 831-8242 fax (302) 831-8251 Web site: http://seurat.art.udel.edu

Wilmington: Delaware Art Museum; 2301 Kentmere Pkwy. 19806 (302) 571-9590

District of Columbia

The Corcoran Gallery of Art; 17 St. & New York Ave., NW 20006 (202) 638-3211 Web site: www.umich.edu/~hartspc/umsdp/CN.html

Freer Gallery of Art; Jefferson Dr. & 12th St. SW 20560 (202) 357-4880 TDD (202) 786-2374 Web site: www.si.edu/asia

Hirshhorn Museum and Sculpture Garden Smithsonian Institution; Independence Ave. at 7th St. SW 20560 (202) 357-3091 fax (202) 786-2682 Web site: www.corcoran.edu/cga/index.htm

Howard University Gallery of Art; 2455 6th St., NW 20059 (202) 636-7047 Web site: www.howard.edu/finearts/GALLERy_FINAL/GalleryofArt.html

National Gallery of Art; 4th St. and Constitution Ave. NW 20565 (202) 737-4215 Web site: www.nga.gov/programs/programs.htm

National Museum of African Art Smithsonian Institution; 950 Independence Ave SW 20560 (202) 357-4600 Web site: www.si.edu/nmafa

National Museum of Women in the Arts; 1250 New York Ave., NW 20005 (202) 783-5000 Web site: www.nmwa.org

Smithsonian Institution; 1000 Jefferson Dr. 20560 (202) 357-1300 Web site: www.simsc.si.edu/msc/msc.html

Florida

Boca Raton: Boca Raton Museum of Art; 801 W. Palmetto Part Rd. 33486 (407) 392-2500 fax (561) 391-6410 Web site: www.bocamuseum.org/page2.htm

Coral Gables: The Florida Museum of Hispanic and Latin American Art; 4006 Aurora St. 33146 (305) 444-7060 fax (305) 261-6996 Web site: www.latinweb.com/museo

Fort Lauderdale: Museum of Art; 1 E. Las Olas Blvd. 33301 (305) 525-5500

Jacksonville: Jacksonville University Alexander Brest Gallery and Museum; 2800 University Blvd N. (904) 744-3950 fax (904) 745-7375 Web site: http://junix.ju.edu/JU/abmg.htm

Miami: Miami Center for the Fine Arts; 101 W. Flagler St. 33130 (305) 375-1700 fax (305) 375-1725

Miami: Miami-Dade Community College Kendall Campus Art Gallery; 11011 SW 104th St. 33176-3393 (305) 237-2322 Web site: www.artcom.com/museums/nv/gl/33176-33.htm

Miami: Miami-Dade Community College Wolfson Galleries; 300 NE 2nd Ave. 33132 (305) 237-3278 fax (305) 237-3603

Miami Beach: Bass Museum of Art; 2121 Park Ave. 33139 (305) 673-7530 fax (305) 673-7062 Web site: http://ci.miami-beach.fl.us

Orlando: Orlando Museum of Art; 2416 N. Mills Ave. 32803 (407) 896-4231 fax (407) 896-9920 Web site: http://omart.org

St. Petersburg: Salvador Dali Museum; 1000 3rd St. S. 33701 (813) 823-3767 Web site: www.daliweb.com

Tallahassee: Florida State University Museum of Fine Arts; Copeland and W. Tennessee 32306-1140 (850) 644-6836 fax (850) 644-7229 Web site: www.fsu.edu/~svad/FSUMuseum/FSU_Museum.html

Tampa: Tampa Museum of Art; 600 N. Ashley Dr. 33602 (813) 274-8130 fax (813) 274-8732 Web site: www.artcom.com/museums/nv/sz/33602-43.htm

Georgia

Athens: Georgia Museum of Art; The University of Georgia, Jackson St. 30602 (404) 542-3255 Web site: www.uga.edu/gamuseum

Atlanta: The High Museum of Art; 1280 Peachtree St., NE 30309 (404) 892-3600 Web site: www.atlcater.com/hmoa.htm

Augusta: Morris Museum of Art; 1 Tenth St. 30901-1134 (706) 7501 fax (706) 724-7612 Web site: www.themorris.org/

Gainsville: Brenau University Galleries; One Centennial Circle 30501 (770) 534-6263 fax (770) 534-6114 Web site: www.brenau.edu/

Hawaii

Honolulu: Honolulu Academy of Arts; 900 S. Beretania St. 96814 (808) 538-3693 Web site: www.honoluluacademy.org

Honolulu: University of Hawaii Art Gallery; 2535 The Mall 96822 (808) 948-6888 Web site: www2.hawaii.edu/artgallery/

Idaho

Boise: Boise Art Museum; 670 S. Julia Davis Dr. 83702 (208) 345-8330 Web site: www.boiseartmuseum.org

Moscow: University of Idaho Prichard Art Gallery; 414/416 S. Main St. 83843 (208) 885-3586 Web site: www.uidaho.edu/larch/cat/news/prichard.html

Illinois

Bloomington: Illinois Wesleyan University Merwin and Wakeley Galleries; 61702-2900 (309) 556-3077 E-mail: kfrench@titon.iwu.edu

Champaign: Krannert Art Museum; University of Illinois, 500 E. Peabody St. 61820 Web site: www.artcom.com/museums/nv/gl/61820-69.htm

Chicago: Art Institute of Chicago; Michigan Ave. and Adams St. 60603 (312) 443-3600 Web site: www.artic.edu

Chicago: Loyola University of Chicago The Martin D'Arcy Gallery of Medieval, Renaissance and Baroque Art; 6525 N. Sheridan Rd. 60626 (773) 508-2679 Web site: www.luc.edu/depts/darcy

Chicago: Museum of Contemporary Art; 237 E. Ontario St. 60611 (312) 280-2660 Web site: http://mcachicago.org

Chicago: Northern Illinois University Art Gallery in Chicago; 215 Superior St. 3rd floor 60610 (312) 642-6010 Web site: www.vpa.niu.edu/museum

Evanston: Northwestern University Mary and Leigh Block Museum of Art; 1967 South Campus Dr. on the Arts Circle 60208-2261 (847) 491-4000 Web site: http://www.nwu.edu/museum/collections/index.html

Normal: Illinois State University Galleries; 110 Center for the Visual Arts 61790 (309) 438-5487 Web site: www.orat.ilstu.edu/cfa/galleries

Springfield: Illinois State Museum; Spring and Edward Sts. 62706 (217) 782-7386 Web site: www.museum.state.il.us/

Urbana: University of Illinois World Heritage Museum; 484 Lincoln Hall 702 Wright St. 61801 (217) 333-2360 Web site: www.uiuc.edu/WHM/home.html

Indiana

Bloomington: Indiana University Art Museum; 47405 (812) 855-5445 Web site: www.indiana.edu/~iuam

Indianapolis: Eiteljorg Museum of American Indian and Western Art; 500 W. Washington 46204 (317) 636-9378 Web site: www.eiteljorg.org

Indianapolis: Indianapolis Museum of Art; 1200 W. 38th St. 46208 (317) 923-1331 Web site: www.ima-art.org

Muncie: Ball State University Art Gallery; 200 University Ave. 47306 (317) 285-5242 Web site: www.bsu.edu/cfa/museum/index.html

Notre Dame: University of Notre Dame Snite Museum of Art; 46556 (219) 631-5466 fax (219) 631-8501 Web site: www.nd.edu/~sniteart

Terre Haute: Indiana State University Art Gallery; 47809 (812) 237-3720 fax (812) 237-4369 Web site: http://gallery.indstate.edu/

Iowa

Ames: Iowa State University Brunnier Art Museum; Iowa State Center, Scheman Continuing Education Bldg 50011 (515) 294-3342 Web site: www.museums.iastate.edu/

Des Moines: Des Moines Art Center; 4700 Grand Ave. 50319 (515) 277-4405 Web site: www.artcom.com/museums/nv/af/50312-20.htm

Iowa City: University of Iowa Museum of Art; North Riverside Dr. 52242 (319) 335-1727 Web site: www.uiowa.edu/~artmus

Kansas

Lawrence: University of Kansas Spencer Museum of Art; 1301 Mississippi St. 66045 (913) 864-4710 Web site: www.cc.ukans.edu/~sma

Wichita: Wichita Art Museum; 619 Stackman Dr. 67203 (316) 268-4921 Web site: www.tfaoi.com/nmus19.htm

Wichita: Wichita State University Edwin A. Ulrich Museum of Art; 1845 Fairmount 67260-0046 (316) 978-3664 Web site: www.twsu.edu/~ulrich

Kentucky

Bowling Green: Western Kentucky University The Kentucky Museum; 42101 (502) 745-2592 Web site: www2.wku.edu/www/library/museum/art_coll.htm

Lexington: University of Kentucky Art Museum; Rose and Euclid 40506 (606) 257-5716

Louisville: Louisville Visual Art Association; 3005 River Rd 40207 (502) 581-1445 Web site: www.louvsart.org

Murray: Murray State University Art Galleries; Price Doyle Fine Arts Center PO Box Q 42071-0009 (502) 762-3052 fax (502) 762-3920

Louisiana

Alexandria: Alexandria Museum of Art; 933 Main St. 71301 (318) 443-3458

Alexandria: Louisiana State University at Alexandria Gallery; Student Center, Hwy 71 S 71302 (318) 473-6449

New Orleans: New Orleans Museum of Art; 1 Collins Diboll Circle, City Park 70124 (504) 488-2631 fax (504) 484-6662 Web site: www.noma.org

Shreveport: Casa d'Arte Gallery; 513 Spring St. 71101 (318) 424-6415 Web site: www.casadarte.com

Shreveport: Centenary College Meadows Museum of Art; 2911 Centenary Blvd 71104 (318) 869-5169 Web site: www.centenary.edu

Maine

Brunswick: Bowdoin College Museum of Art; Walker Art Bldg 04011 (207) 725-3275 fax (207) 725-3762 Web site: www.bowdoin.edu/cwis/resources/museums.html

Portland: Portland Museum of Art; Seven Congress Square 04101 (207) 775-6148 Web site: www.portlandmuseum.org

Maryland

Baltimore: The Baltimore Museum of Art; Art Museum Dr. 21218 (301) 396-7101 Web site: www.artbma.org

Baltimore: The Walters Art Gallery; 600 North Charles St., 21201 (410) 547-9000 Web site: www.thewalters.org

Baltimore: University of Maryland/Baltimore County Albin O. Kuhn Library & Gallery; 1000 Hilltop Circle98 21250 (410) 455-2270 Web site: http://umbc7.umbc.edu/~curnoles/gallery.html

College Park: University of Maryland University College Arts Program; University Blvd at Adelphi Rd 20742-1600 (301) 985-7822 fax (301) 985-7678 Web site: www.umuc.edu/art/index.html

Massachusetts

Amherst: Amherst College Mead Art Museum; 01002 Web site: www.amherst.edu/~mead/

Amherst: University of Massachusetts Amherst Herter Art Gallery; 125A Herter Hall 01003 (413) 545-0976 fax (413) 253-3929

Boston: Boston University Art Gallery; 602 Commonwealth Ave 02215 (617) 353-3329

Boston: Museum of Fine Arts; 465 Huntington Ave. 02115 (617) 267-9300 Web site: www.swift-tourism.com/mfa.htm

Cambridge: Arthur M. Sackler Museum; 485 Broadway 02138 (617) 495-9400 Web site: www.artmuseums.harvard.edu/Sackler_Pages/SacklerMain.html

Cambridge: Harvard University Fogg Art Museum; 32 Quincy St. 02138 (617) 253-4680 Web site: www.cityinsights.com/bofoggmu.htm

Framingham: Danforth Museum of Art; 123 Union Ave. 01701 (508) 620-0050

Northhampton: Smith College Museum of Art; 01063 (413) 2760 Web site: www.smith.edu/artmuseum

Springfield: Museum of Fine Arts The Springfield Museums of the Quadrangle; corner of State and Chestnut 01103 (413) 732-6092 Web site: www.spfldlibmus.org

Waltham: Brandeis University Rose Art Museum; MS 69 02254 (781) 736-3434 Web site: www.brandeis.edu/rose/collection.html

Worchester: Worchester Art Museum; 55 Salisbury Rd. 01609 (508) 799-4406

Michigan

Ann Arbor: University of Michigan Museum of Art; 525 S. State St. 48109 (313) 764-0395 Web site: www.umich.edu/~umma/

Detroit: Detroit Institute of Arts; 5200 Woodward Ave. 48202 (313) 833-7900 Web site: www.dia.org

East Lansing: Michigan State University Kresge Art Museum; Auditorium and Physics Roads 48824 (517) 355-7631 Web site: www.msu.edu/unit/kamuseum/

Pontiac: The Next Museum of Contemporary Art; 23 W. Lawrence Ave. 48342 (248) 334-6038

Saginaw: Saginaw Art Museum; 1126 N. Michigan Ave. 48602 (517) 754-2491 Web site: http://members.xoom.com/SaginawArt/

Traverse City: Northwestern Michigan College Dennos Museum Center; 1701 E. Front St. 49686 (616) 922-1055 Web site: www.dmc.nmc.edu

Minnesota

Duluth: University of Minnesota at Duluth Tweed Museum of Art; 10 University Dr. 55812 (218) 726-8222 Web site: http://www.d.umn.edu/tma

Minneapolis: Minneapolis Institute of Arts; 2400 Third Ave. So. 55404 (612) 374-5547 Web site: www.arts.MIA.org/

Minneapolis: University of Minnesota, Minneapolis Frederick R. Weisman Art Museum; 333 E. River Rd. 55455 (612) 625-9494 Web site: http://hudson.acad.umn.edu

Minneapolis: Walker Art Center; Vineland Place 55403 (612) 375-7622

St. Paul: Minnesota Museum of American Art; Fifth and Market 55102 (612) 292-4355 Web site: http://twincities.sidewalk.com/detail/16408

Mississippi

Jackson: Mississippi Museum of Art; 201 E. Pascagoula St. 39201 (601) 960-1515 Web site: www.msmuseumart.org/

University: University Museums; The University of Mississippi 38677 (601) 232-7073 Web site: www.olemiss.edu/depts/u_museum

Missouri

Columbia: Museum of Art and Archaeology; University of Missouri 65211 (314) 882-3591

Kansas City: Kemper Museum of Contemporary Art; 4420 Warwick Blvd. 64111-1821 (816) 561-3737 Web site: www.kemperart.org

Kansas City: Nelson-Atkins Museum of Art; 4525 Oak St. 64111 (816) 561-4000 Web site: www.nelson-atkins.org

Springfield: Springfield Art Museum; 1111 E. Brookside Dr. 65807 (417) 886-2716

St. Joseph: The Albrecht-Kemper Museum of Art; 2818 Frederick Ave. 64506 (816) 233-7003 Web site: www.albrecht-kemper.org

St. Louis: St. Louis Art Museum; 1 Fine Arts Dr., Forest Park 63110 (314) 721-0067 Web site: www.slam.org

Montana

Missoula: Art Museum of Missoula; 335 N. Pattee 59802 (406) 728-0447

Missoula: University of Montana, Missoula School of Fine Arts; 59812, Web site: www.umt.edu/partv/famus

Nebraska

Lincoln: University of Nebraska Sheldon Memorial Art Gallery and Sculpture Garden; 12th & R Sts. 68588-0300 (402) 472-2461

Omaha: Joslyn Art Museum; 2200 Dodge St. 68102 (402) 342-3300
Web site: www.joslyn.org

Nevada

Las Vegas: Las Vegas Art Museum; 3333 W. Washington 89107
(702) 647-4300

Las Vegas: University of Nevada at Las Vegas Donna Beam Fine
Art Gallery; 4505 Maryland Pkwy 89154 (702) 895-3893 Web
site: www.nscee.edu/unlv/Art/gallery/html

Reno: University of Nevada at Reno Sheppard Art Gallery; Dept.
of Art 89557 (702) 784-6658

New Hampshire

Durham: University of New Hampshire The Art Gallery; 30
College Rd. 03824 (603) 862-3712 fax (603) 862-2191

Hanover: Dartmouth College Hood Museum of Art; 03755 (603)
646-2808

Manchester: The Currier Gallery of Art; 201 Myrtle Way 03104
(603) 669-6144 Web site: www.fedarts.com/?currier.htm

New Jersey

Montclair: Montclair Art Museum; 3 South Mountain Ave. 07042
(201) 746-5555 Web site: www.montclair-art.com

Morristown: Morris Museum; 6 Normandy Heights Rd. 07960
(973) 538-0454 Web site: www.morrismuseum.org/

Newark: The Newark Museum; 49 Washington St. 07101 (973)
596-6550 (800) 7MUSEUM

Newark: Rutgers University Robeson Center Art Gallery; 350 Dr.
Martin Luther King Jr. Blvd. 07102 (973) 353-5119, ext 32 fax
(973) 353-1610

Princeton: Princeton University The Art Museum 08544 (609) 258-
3788

Trenton: New Jersey State Museum; 205 W. State St. CN 530 08625
(609) 292-6300 Web site:
www.state.nj.us/state/museum/musidx.html

New Mexico

Albuquerque: University Art Museum; The University of New
Mexico 87131 (505) 277-4001

Las Cruces: New Mexico State University Art Gallery; Williams
Hall 88003 (505) 646-2545 fax (505) 646-8036 Web site:
www.nmsu.edu/Campus_Life/artgal.html

Santa Fe: Museum of Fine Arts; 107 W. Palace 87501 (505) 827-4468

Santa Fe: The Next Museum at Santa Fe; 1 Balsa Rd. 87505 (505) 466-9909

Taos: University of New Mexico Harwood Foundation Museum; 238 Ledoux St., NDCBU 4080 87571 (505) 758-9826 fax (505) 758-1475

New York

Albany: Albany Institute of History & Art; 125 Washington Ave. 12210 (518) 463-4478 Web site: www.albanyinstitute.org

Albany: State University of New York at Albany Art Museum; 1400 Washington Ave. 12222 (518) 442-4035 fax (518) 442-5075

Binghamton: State University of New York at Binghamton University Art Museum; Fine Arts Building 13902-6000 (607) 777-2634 Web site: www.artcom.com/museums/nv/sz/13902-60.htm

Brooklyn: Brooklyn Museum of Art; 200 Eastern Pkwy 11238 (718) 638-5000 Web site: www.brooklynart.org

Buffalo: Albright-Knox Art Gallery; 1285 Elmwood Ave. 14222 (716) 882-1958 Web site: www.albrightknox.org/

Buffalo: CEPA Gallery Center for Exploratory and Perceptual Art; 617 Main St., Suite 201 14203. Web site: www.cepa.buffnet.net

Flushing: Queens College/City University of New York Art Center, Benjamin S. Rosenthal Library 65-30 Kissena Blvd 11367 (718) 997-ARTS Web site: www.qc.edu/library/art/center

Hempstead: Hofstra University Museum; 112 Hofstra University 11549 (516) 792-1761 fax (516) 463-4832 Web site: www.artcom.com/museums/nv/gl/11550-10.htm

Huntington: Heckscher Museum; 2 Prime Ave. 11743-7702 (516) 351-3250 Web site: www.heckscher.org

New York City: The Cloisters; 190 3rd St. - Fort Tryon Park 10040 (212) 923-3700 Web site: www.metmuseum.org/htmlfile/gallery/cloister/cloister.html

New York City: The Frick Collection; 1 E. 70th St. 10021 (212) 288-0700 Web site: www.frick.org

New York City: Solomon R. Guggenheim Museum; 1071 Fifth Ave. 10128 (212) 360-3500 Web site: www.guggenheim.org

New York City: International Center of Photography; 1130 Fifth Ave. 10128

New York City: The Metropolitan Museum of Art; Fifth Ave. at 82nd St. 10028 (212) 879-5500 Web site: www.metmuseum.org

New York City: Museum for African Art; 593 Broadway 10012 (212) 966-1313

New York City: The Museum of Modern Art; 11 W. 53rd St. 10019 (212) 708-9400 Web site: www.moma.org

New York City: New York University Grey Art Gallery; 100 Washington Square E. 10003 (212) 998-6780 Web site: www.nyu.edu/greyart

New York City: Whitney Museum of American Art; 945 Madison Ave. 10021 (212) 570-3600 Web site: www.echonyc.com/~whitney/

Potsdam: State University of New York, College at Potsdam Roland Gibson Gallery; (315) 267-2245 Web site: www.potsdam.ny.us/gallery/

Poughkeepsie: Vassar College The Frances Lehman Loeb Art Center; 124 Raymond Ave. 12604-0023 Web site: http://vassun.vassar.edu/~fllac/

Rochester: George Eastman House; 900 East Ave. 14607 (716) 271-3361

Rochester: The Strong Museum; One Manhattan Sq. 14607 (716) 263-2700 Web site: www.strongmuseum.org/

Rochester: University of Rochester Memorial Art Gallery; 500 University Ave. 14607 (716) 473-7720 Web site: www.rochester.edu/MAG/

Southampton: The Parrish Art Museum; 25 Jobs Lane 11968 (516) 283-2118 Web site: http://thehamptons.com

Stony Brook: Museums at Stone Brook Art Museum, Carriage Museum, History Museum; 1208 Route 25A 11790 Web site: www.museumsatstonybrook.org/

North Carolina

Asheville: Asheville Art Museum; 2 S. Pack Sq. 28802 (704) 253-3227 Web site: www.main.nc.us/asheville_art/

Chapel Hill: University of North Carolina at Chapel Hill Ackland Art Museum; Campus Box 3400 27599-3400 (919) 966-5736 Web site: www.unc.edu/depts/ackland/

Charlotte: Mint Museum of Art; 2730 Randolph Rd. 28207 (704) 337-2000 Web site: www.mintmuseum.org

Durham: Duke University Museum of Art; Box 90732 27708 (919) 684-5135 Web site: www.duke.edu/web/duma

Greensboro: The University of North Carolina at Greensboro Weatherspoon Gallery; Spring Garden St. at Tate St. 27402 (336) 334-5770 Web site: www.uncg.edu/wag/

Raleigh: North Carolina Museum of Art; 2110 Blue Ridge Blvd. 27607 (919) 833-1935 Web site: www2.ncsu.edu/NCMA/

North Dakota

Bismarck: Bismarck State College Gannon/Elsa Forde Galleries; 1500 Edwards Ave. 58501 (701) 224-5520 E-mail: mlindblo@prairie.nodak.edu

Grand Forks: North Dakota Museum of Art; University of North Dakota 58202 (701) 777-3650 Web site: www.artcom.com/museums/nv/mr/58202.htm

Ohio

Akron: Akron Art Museum; 70 E. Market St. 44308-2084 (330) 367-9185 Web site: www.akronartmuseum.org

Berea: Baldwin-Wallace College Fawick Gallery; 275 Eastland Rd. 44017 (216) 826-2152

Cincinnati: Cincinnati Art Museum; Eden Park 45202 (513) 721-5204 Web site: www.cincinnatiartmuseum.org

Cleveland: The Cleveland Museum of Art; 11150 East Blvd. 44106 (216) 421-7340 Web site: www.clemusart.com/

Columbus: Capital University Schumacher Gallery; 2199 E. Main St. 43209 (614) 236-6319

Columbus: Columbus Museum of Art; 480 E. Broad St. 43215 (614) 221-6801 Web site: www.columbusart.mus.oh.us/

Columbus: The Ohio State University Wexner Center for the Arts; 1871 N. High St. 43210 (614) 292-0330 Web site: www.wexarts.org/

Kent: Kent State University School of Art Gallery; Art Building 44242 (330) 672-7853 Web site: www.kent.edu/museum/

Toledo: The Toledo Museum of Art; 2445 Monroe St. 43620 (419) 225-8000 Web site: www.toledomuseum.org

Youngstown: Butler Institute of American Art; 524 Wick Ave. 44502 (330) 743-1107 Web site: www.butlerart.com/

Youngstown: Youngstown State University The John J. McDonough Museum of Art; One University Plaza 44555 (330) 742-1400 Web site: www.ysu.edu.

Zanesville: Zanesville Art Center; 620 Military Rd. 43701 (740) 452-0741

Oklahoma

Norman: University of Oklahoma Fred Jones Jr. Museum of Art; 410 W. Boyd St. 73019 (405) 325-3272 Web site: www.ou.edu/fjjma

Oklahoma City: Oklahoma City Art Museum; 3113 Pershing Blvd 73107 (405) 946-4477 Web site: www.okccvb.org/ocam.html

Tulsa: Philbrook Museum of Art; 2727 S. Rockford Rd. 74114 (918) 749-7941 Web site: http://tulsaweb.com/phbrook.htm

Oregon

Eugene: University of Oregon Museum of Art; 1430 Johnson Ave. 97403 (503) 686-3027 Web site: http://uoma.uoregon.edu/

Portland: Portland Art Museum; 1219 SW Park Ave. 97205 (503) 226-2811 Web site: www.pam.org/

Pennsylvania

Bethlehem: Lehigh University Zoellner Arts Center; 420 E. Packer Ave. 18015 (610) 758-3615 Web site: www.lehigh.edu/Zoellner/

Chadds Ford: Brandywine River Museum; US Route 1 19317 (610) 388-2700 Web site: www.brandywinemuseum.org

Harrisburg: The State Museum of Pennsylvania; 3rd and N Sts. 17108 (717) 787-4980 Web site: www.paheritage.com/dastate.html

Erie: Erie Art Museum; 411 State St. 16501 (814) 459-5477 Web site: www.erie.net/~erieartm/

Philadelphia: Philadelphia Museum of Art; 26th St. and the Parkway 19130 (215) 763-8100 Web site: http://pma.libertynet.org/

Philadelphia: University of Pennsylvania Arthur Ross Gallery; 220 S. 34th St. 19104-6303 Web site: www.upenn.edu/ARG/index.html

Pittsburgh: The Carnegie Museum of Art; 440 Forbes Ave. 15213 (412) 622-3200 Web site: www.clpgh.org/cma/

Reading: Reading Public Museum; 500 Museum Rd. 19611 (610) 371-5850 Web site: www.berks.net/museum/

Puerto Rico

Rio Piedras: University of Puerto Rico Museum of Anthropology, History and Art; Box 21908 UPR 00931 (787) 764-0000

Rhode Island

Kingston: University of Rhode Island Fine Arts Center Galleries; 105 Upper College Rd. Suite 1 02881-0820 (401) 874-2775 fax: (401) 874-2729

Providence: Brown University David Winton Bell Gallery, List Art Center; 64 College St. 02912-1861 (401) 863-2932 Web site: www.brown.edu/Facilities/David_Winton_Bell_Gallery/index.html

Providence: Museum of Art; Rhode Island School of Design, 224 Benefit St. 02903 (401) 331-3511 Web site: www.risd.edu/museum.html

South Carolina

Columbia: Columbia Museum of Art; 1112 Bull St. 29201 (803) 799-2810 Web site: www.colmusart.org

Columbia: South Carolina State Museum; 301 Gervais St. 29202 (803) 737-4921 Web site: www.museum.state.sc.us/

Columbia: University of South Carolina McKissick Museum; 29208 Web site: www.cla.sc.edu/mcks/index.html

Greenville: Greenville County Museum of Art; 420 College St. 29601 (864) 271-7570 Web site: http://greatergreenville.com/virtual_tour/artmuse.html

Spartanburg: University of South Carolina Spartanburg Art Gallery; 800 University Way 29303 (864) 503-5838

South Dakota

Brookings: South Dakota Art Museum; Medary Ave. at Dunn St. 57007 (605) 688-5423

Vermillion: University Art Galleries; University of South Dakota 57069 (605) 677-5636

Tennessee

Chattanooga: Hunter Museum of Art; 10 Bluff View 37403 (615) 267-0968 Web site: www.huntermuseum.org

Chattanooga: University of Tennessee at Chattanooga Cress Gallery of Art; 615 McCallie Ave. 37403 (423) 755-4178 Web site: www.utc.edu/cressgallery/

Knoxville: Knoxville Museum of Art; 1010 Laurel Ave. 37916 (615) 525-6101 Web site: www.knoxart.org

Knoxville: University of Tennessee C. Kermit Ewing Gallery of Art and Architecture; 1715 Volunteer Blvd. 37996 (423) 974-3200 Web site: funnelweb.utcc.utk.edu/~spangler/default.html

Memphis: Memphis Brooks Museum of Art; Overton Park 38112 (901) 722-3525 Web site: www.brooksmuseum.org

Memphis: University of Memphis Art Museum; CFA 142, 3750 Norriswood 38152 Web site: www.people.memphis.edu/~artmuseum/AMHome.html

Nashville: Vanderbilt University Fine Art Gallery; 23rd and West End Avenues 37203 (615) 322-0605 fax (615) 343-1382

Sewanee: University of the South University Gallery; 735 University Ave. 37383 (615) 598-1223 Web site: www.sewanee.edu/artdept

Texas

Austin: Austin Museum of Art Laguna Gloria; 3809 W. 35th St. 78763 (512) 495-9224 Web site: www.amoa.org

Austin: University of Texas at Austin Jack S. Blanton Museum of Art; 23rd and San Jacinto 78712 Web site: www.utexas.edu/cofa/hag

College Station: Texas A & M University J. Wayne Stark University Center Galleries; PO Box J-3 77844 Web site: www.stark.tamu.edu

Dallas: Dallas Museum of Art; 1717 N. Harwood 75201 (214) 922-0220 Web site: www.dm-art.org

Dallas: Southern Methodist University Meadows Museum; Meadows School of the Arts 75272 (214) 768-2516 Web site: www.smu.edu/meadows/museum/

Fort Worth: Kimbell Art Museum; 3333 Camp Bowie Blvd. 76107 (817) 332-8451 Web site: www.kimbellart.org/

Houston: Museum of Fine Arts; 1001 Bissonnet 77005 (713) 526-1361 Web site: www.mfah.org

Houston: Rice University Art Gallery; 6100 Main St. MS-59 77005 (713) 527-6069 Web site: www.rice.edu/ruag

Houston: University of Houston Blaffer Gallery, The Art Museum of the University of Houston; 4800 Calhoun 77204 (713) 743-9530 Web site: www.hfac.uh.edu/blaffer

Lubbock: Texas Tech University Landmark Arts: Galleries of the Department of Art; PO Box 42081 79409 (806) 742-1947 Web site: www.art.ttu.edu/artdept/lndmrk.html

San Antonio: ArtPace, A Foundation for Contemporary Art; 445 N. Main Ave. 78205 (210) 212-4900 Web site: www.artpace.org

Utah

Provo: Brigham Young University Museum of Fine Arts; Harris Fine Arts Center 84602 (801) 378-2818 Web site: www.byu.edu/moa/

Salt Lake City: University of Utah Museum of Fine Arts; 84112 (801) 581-7332 Web site: www.utah.edu/umfa/

Vermont

Burlington: University of Vermont Robert Hull Fleming Museum; 61 Colchester Ave. 05405 (802) 656-2090

Middlebury: Middlebury College Museum of Art; Center for the Arts 05753 (802) 443-5007 Web site: www.middlebury.edu/~museum

Montpelier: Vermont College T. W. Wood Gallery & Arts Center; College Hall 05602 (802) 828-8743

Virginia

Charlottesville: University of Virginia Bayly Art Museum; 22903 (804) 924-3592 Web site: www.virginia.edu/~bayly/bayly.html

Norfolk: The Chrysler Museum of Art; 245 W. Olney Rd. 23510 (757) 664-6200 Web site: www.chrysler.org

Richmond: Virginia Museum of Fine Arts; 2800 Grove Ave. 23221 (804) 367-0844 Web site: www.state.va.us/vmfa

Roanoke: Art Museum of Western Virginia Center in the Square; One Market Square 24011 (540) 342-5760 Web site: www.CITS.org/artmuse.html

Williamsburg: College of William and Mary Muscarelle Museum of Art; 23187 (804) 221-2700 Web site: http://warthog.cc.wm.edu/muscarelle/

Washington

Pullman: Museum of Art; Washington State University 99164 (509) 335-1910

Seattle: Seattle Art Museum; 100 University St. 98101 (206) 654-3100 Web site: www.seattleartmuseum.org/

Seattle: University of Washington Burke Museum; corner of 17th Ave. NE and NE 45th St. 98195 (206) 654-3100 Web site: www.washington.edu/burkemuseum/

Spokane: Gonzaga University Jundt Art Museum; 202 E. Cataldo Ave. 99258 (509) 328-4220 Web site: www.gonzaga.edu/jundt/

Tacoma: Tacoma Art Museum; 1123 Pacific Ave. 98402 (253) 272-4258 Web site: www.tacomaartmuseum.org

West Virginia

Charleston: Sunrise Museum; 746 Myrtle Rd. 25314 (304) 344-8035 Web site: www.astc.org/trguide/wv10124.htm

Huntington: Huntington Museum of Art; 20233 McCoy Rd. 25701 (304) 529-2701 Web site: www.artcom.com/museums/nv/gl/25701-49.htm

Wisconsin

Beloit: Beloit College Wright Museum of Art; 700 College St. 53511 (608) 363-2677 Web site: www.beloit.edu/~wright/

Green Bay: University of Wisconsin at Green Bay Galleries; 2420 Nicolet Dr. 54311 (920) 465-2916

Madison: Madison Art Center; 211 State St. 53703 (608) 257-0158 Web site: www.madisonartcenter.org

Madison: University of Wisconsin—Madison Wisconsin Union Galleries; 800 Langdon St. 53706 (608) 262-5969 Web site: http://polyglot.lss.wisc.edu/slavic/pages/3lvm.html

Milwaukee: Milwaukee Art Museum; 750 N. Lincoln Memorial Dr. 63202 (414) 271-9508 Web site: www.mam.org

Oshkosh: University of Wisconsin Oshkosh Allen Priebe Gallery; 800 Algoma Blvd. 54901 (414) 424-2235

Whitewater: University of Wisconsin—Whitewater Crossman Gallery, Center of the Arts 950 W. Main St. 53190 (414) 472-5708 Web site: www.uww.edu

Wyoming

Cheyenne: Wyoming State Museum; Barrett Building, 2301 Central Ave. 82002 (307) 777-7022 Web site: http://commerce.state.wy.us/cr/wsm/index.htm

Laramie: University of Wyoming Art Museum; Centennial Complex, 2111 Willet Dr. 82071 (307) 766-6622 Web site: www.uwyo.edu/artmuseum

A list of museums in the United States, organized by state, is available at www.museumlink.com/states.htm. To access current exhibitions online, try www.artmuseum.net. Tour an online gallery of twentieth-century masterpieces at www.art.com.

NOTES AND SKETCHES

INDEX